WASHINGTON ICONS

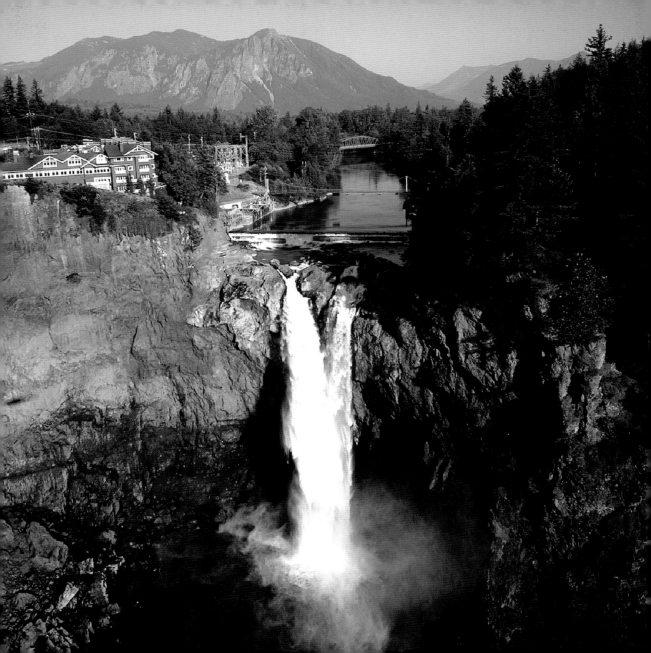

WASHINGTON ICONS

50 CLASSIC VIEWS
OF THE EVERGREEN STATE

Harriet Baskas

Guilford, Connecticut

To buy books in quantity for corporate use
or incentives, call **(800) 962-0973**
or e-mail **premiums@GlobePequot.com.**

Slinky is a registered trademark of Poof-Slinky Inc.

Project editor: Jessica Haberman
Text design and layout: Casey Shain

Library of Congress Cataloging-in-Publication Data
Baskas, Harriet.
 Washington icons : 50 classic views of the Evergreen State / Harriet Baskas.
 p. cm.
 ISBN 978-0-7627-4968-3
 1. Washington (State)—History—Pictorial works. 2. Washington (State)—Pictorial works. 3. Washington (State)—Description and travel—Pictorial works. I. Title.
 F892.B38 2010
 979.7—dc22

 2009029532

Printed in China

10 9 8 7 6 5 4 3 2 1

*To the generous and smart folks at MOHAI, HistoryLink.org,
the Washington State History Museum, and elsewhere who shared
their knowledge of and enthusiasm for our state's many treasures.*

CONTENTS

INTRODUCTION

Whether you're a Washingtonian or not, it's a fair bet that the first things that come to mind when you see the title *Washington Icons* are rain, coffee, and Mount St. Helens. Each is most definitely an icon—"an important and enduring symbol"—and each is inextricably intertwined with the history and culture of the Evergreen State. If you think about it just a little longer, there are lots more. What about apples, orcas, wild salmon, and Sasquatch? The historic Pike Place Market, the landmark Space Needle, and all those record-setting old-growth trees? Yup, we need to add those to the list.

When I first began gathering nominations for the Washington State icons to include in this lovely illustrated book (thank you, photographer Sharon Wootton), I thought it was a simple assignment: List fifty things you love about the state of Washington and write short essays describing the "icon-ness" of each one. Turns out, it wasn't that easy.

I spent a lot of time looking over, rearranging, and reassessing an ever-changing list of possible items to include. I took nominations from far and wide. I mulled over the difference between "interesting," "important," "outstanding," and "icon." And every time I felt as if I had settled on a defini-tion and a list of 50 top "icon-worthy" entries, a half-dozen other places, events, or objects would declare themselves to be not just interesting or important, but outstanding and iconic enough to be moved above the cut-off line.

And then, of course, my definition of icon kept drifting. Can something be an icon if it's smaller than a quarter or ugly as all get-out? Can an icon be a funny-looking building, an almost-extinct animal, or a forest creature that may or may not exist?

The answer is definitely yes. Washington State is not only home to its own fair share of no-question-about-it icons such as Boeing-made airplanes, Starbucks-brewed coffee, and Microsoft-designed software. We've also got the country's wettest forests, biggest trees, and longest drivable beach. We grow the world's best apples, cherries, sweet onions, asparagus, and oysters and we're the state that gave the world the down parka, the racing stroller, and that salvation of necktie manufacturers worldwide: Father's Day.

We Washingtonians aren't just proud of our icons; after neglecting some of them for years we're finally, and often furiously, protective of them too. Our wild salmon runs and our resident orca pods

are now carefully studied and monitored. Several of our architectural follies, including the giant Hat 'n' Boots in Seattle and the Teapot Dome Service Station in Zillah, have well-organized community groups to defend them. And there are strict laws on the books to protect the often feared but always beloved legendary Sasquatch, or Bigfoot, from ever being killed by hunters in the Washington woods.

So if you can agree with my working definition of icons as important and enduring symbols of history and culture that not only tell unique stories but also hold onto the memories of citizens and communities, then you'll definitely enjoy this tour of Washington Icons. My list of fifty may not match yours perfectly, but if I've missed any of your favorites, please let me know.

WASHINGTON ICONS

APPLES

Red or Golden Delicious, Granny Smith or Braeburn. Jonagold, Fuji, Cameo, or Gala. If you've ever eaten any of these apple varieties, they're apt to have come from Washington State, where the apple is the official state fruit.

Each year, Washington's orchards produce ten to twelve billion apples. That's more than half of all the fresh-eating apples grown in the United States each year. And, according to the Washington Apple Commission, if you laid all those apples side by side, they'd circle the planet a dozen times.

But why would anyone want to waste all those apples?

Instead, we keep those crisp, sweet, Washington State apples where we can eat them. But getting them to market isn't all that easy. Most of Washington's apples are grown on about 175,000 acres of orchards in the rich, lava-ash soil on the sunny eastern foot-hills of the Cascade Mountains. And because there is no machine invented

The Washington Apple Commission Visitor Center, Wenatchee www.bestapples .com

Vancouver-Clark Washington Parks and Recreation (360) 619-1111 www.ci.vancouver .wa.us/parks-rec reation

yet that can pick apples, all this fruit must be handpicked from the trees by a workforce that, during the peak harvest weeks, can number between 35,000 and 45,000 people.

Washington's apple attraction may not reach as far back as Adam and Eve, but it does stretch back to the 1800s. In 1826, around the time John Chapman, better known as Johnny Appleseed, was busy planting apple trees back east, a few apple seeds brought from England on a Hudson's Bay Company sailing ship were planted at Fort Vancouver in southwest Washington. A tree that grew from those seeds is now considered to be the oldest apple tree in Washington and in the entire Northwest. The venerable Old Apple Tree (yes, it has a name) sits in Old Apple Tree Park and is celebrated each October during the Old Apple Tree Celebration. During the party, visitors feast on state-grown apples and park officials distribute cuttings snipped from the Old Apple Tree.

APLETS AND COTLETS

In a twist on that old saying, "When life gives you lemons, make lemonade," around 1920 two Armenian immigrants found themselves saddled with a surplus of apples from their orchards and made candy. Almost 90 years later, an old-fashioned factory still cooks up more than two million pounds of that candy—and numerous variations of it—each year.

Armen Tertsagian and Mark Balaban hadn't set out to make their mark in the world by selling sweets. During World War I they helped the war effort by making dehydrated apples that could be easily shipped to soldiers "over there." Later, the company developed Applum, a jam that mixed apples and, you guessed it, plums.

But there were still too many good apples threatening to go bad. So Tertsagian and Balaban put their heads together and worked up a version of a Middle Eastern candy they remembered from their youth. Initially marketed in the Pacific Northwest as the Confection of Fairies, complete with packaging depicting Tinkerbell-like fairies

Liberty Orchards Factory
117 Mission Avenue
(off Highway 2), Cashmere
(800) 231-3243
www.liberty orchards.com

flitting through the orchards, the treat made from apples, walnuts, powdered sugar, and cornstarch was soon renamed Aplets. Cotlets, made from apricots and walnuts, soon followed.

For years, word of mouth and a small mail-order business made boxes of Aplets and Cotlets a steady-selling sweet souvenir of Washington State. But the candies gained hundreds of thousands of new fans after being featured at Century 21, the World's Fair held in Seattle in 1962.

Today, those namesake Aplets and Cotlets, along with versions made with cranberries, strawberries, blueberries, raspberries, grapes, pecans, chocolate, and a variety of other tasty ingredients are still slow-cooked in the Liberty Orchards factory. These days the cooks use four oversize kettles instead of just one and whip up 300 pounds of candy at a time. But after each batch is poured, cooled, cut, and sent to a tumbler for a light coating of cornstarch and powdered sugar, the sweet squares are still placed into boxes by hand.

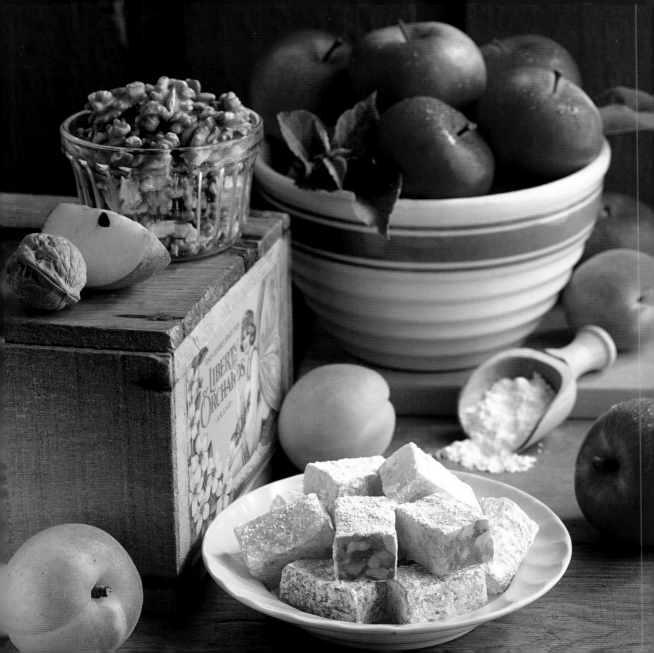

BEACON ROCK

In his journal, William Clark (of Lewis and Clark) described October 31, 1805, as a cloudy, rainy, "disagreeable morning." It was also a significant morning.

The Corps of Discovery had been battling the Columbia River rapids, and that morning, Clark and two corps members hiked ahead on the riverbank to see what was up ahead.

To their relief, they could see "a long distance down the river" and waters that "had every appearance of being effected [*sic*] by the tide." The Pacific Ocean was actually still 150 miles away, but to the explorers this suggested calmer waters ahead.

Something else caught Clark's attention that day on the riverbank: a "remarkable high detached rock . . . about 800 feet high and 400 paces around" that he called Beaten Rock. Native Americans called the rock Che-che-op-tin, or "the naval of the world," but on his way back east in April 1806, Meriwether Lewis stopped by the rock, revised Clark's spelling, and called "this remarkable rock which stands on the North shore of the river" Beacon Rock.

Beacon Rock State Park State Route 14 (thirty-five miles east of Vancouver) (509) 427-8265 www.parks.wa .gov

Several years after Lewis and Clark marveled over what turned out to be an 848-foot volcano core, an expedition sponsored by John Jacob Astor visited the area and renamed the landmark yet again. From 1811 until 1916, Beacon Rock was known as Inoshoack Castle or, more commonly, Castle Rock.

But in 1916, Henry Biddle bought the second-largest monolith in the world after the Rock of Gibraltar, hoping to save it from being blasted away to make way for a road or to make smaller rocks for a jetty. He reclaimed the Beacon Rock name and spent two years building an extremely steep trail to the top. In 1935, Biddle's heirs gave the rock to Washington State (after first offering it to Oregon State) and today Biddle's original trail—nine-tenths of a mile long, with 53 switchbacks—is still there. And while you can't really see the Pacific Ocean from the top of Beacon Rock, on a clear day it offers spectacular views of Mount Hood, the Columbia River Gorge, and the spot on the river that signaled to Lewis and Clark that their epic cross-continental journey might soon be coming to an end.

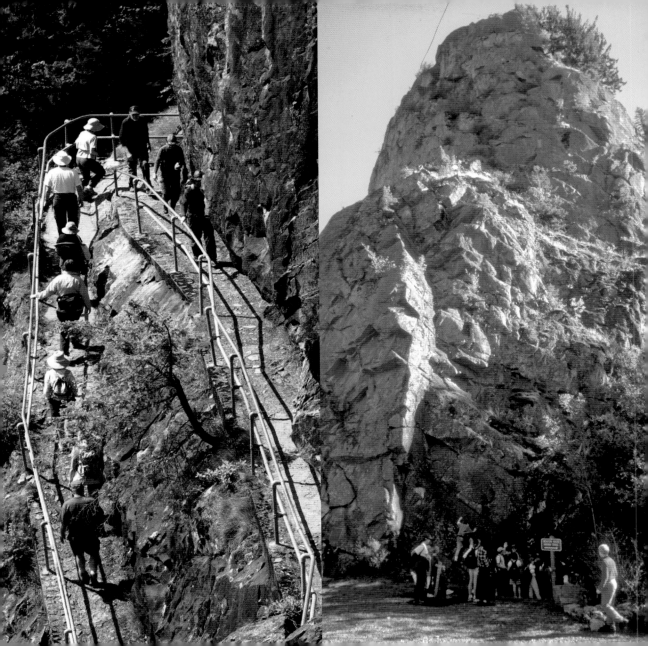

BIGFOOT

Whether you prefer to call it Sasquatch, Bigfoot, or that scary, hairy, eight-foot-tall stinky human/ape monster everyone keeps talking about, one fact remains: For centuries now, people have been claiming that there's definitely some sort of giant unknown Yeti-like creature roaming the Washington woods. Northwest Native American tribes have numerous myths and legends that feature a mysterious forest creature with supernatural powers. And just about every year, some otherwise feet-on-the-ground camper, backcountry hiker, hunter, or nature lover out for an afternoon stroll in the woods returns with a wide-eyed tale about encountering Bigfoot or coming across a huge footprint that is proof positive that some strange beast must really be out there.

Who's to say they're wrong? Sasquatch sightings have been reported in just about every county in just about every state. But for some reason the Bigfoot Field Research Organization, which tallies nationwide sightings, continues to get the most reports from folks in Washington State. As of 2008, there were more than 450 sightings. That, of

Skamania County Chamber of Commerce (800) 989-9178 www.skamania .org

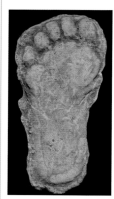

course, doesn't count the folks who may have spotted Bigfoot but didn't report it because they figured no one would believe them anyway.

Most of the sightings that have been reported seem to be clustered in Skamania County's 1.3-million-acre Gifford Pinchot National Forest, which encompasses the Mount St. Helens National Volcanic Monument in the southwest part of the state. That's perhaps why, back in 1969, county officials were moved to pass an ordinance to protect the Sasquatch in what seemed to be its natural habitat. Slaying the creature "generally and commonly known as Sasquatch, Bigfoot, Yeti, or giant hairy ape," was declared to be a felony. The law was amended in 1984 and the creature is now an official endangered species in Skamania County. In fact, the entire county has been declared a Sasquatch Refuge where slaying a Sasquatch is punishable by fines up to $1,000 and/or a prison term of up to one year in jail. The law is tough, but it seems to be working: To date, no Sasquatch, Bigfoot, Yeti, or giant hairy ape has been hunted down and slain in Skamania County.

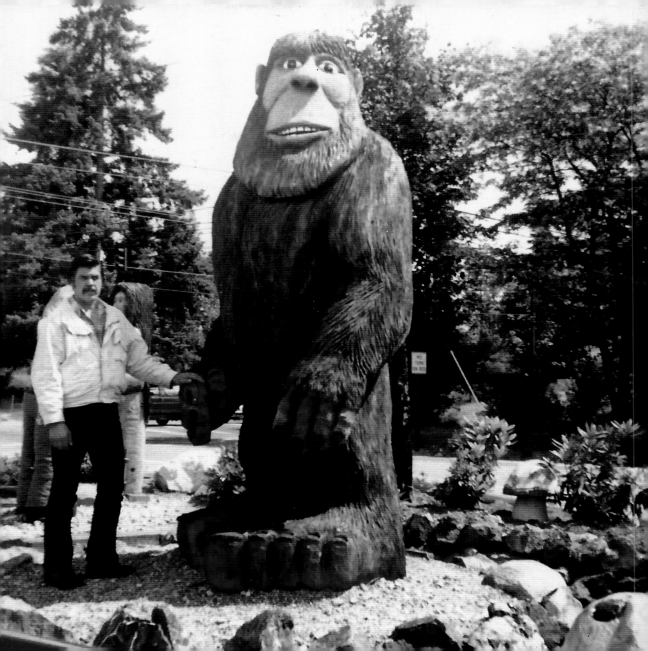

BOBO THE GORILLA

He's six and a half feet tall, furry, fluffed and buffed. And he's stuffed.

But even taxidermied and behind glass, Bobo the gorilla is still one of the state's most beloved icons.

Born in Africa in 1951, Bobo was just two weeks old when he was captured by American gorilla hunter William "Gorilla Bill" Said, who brought Bobo to the United States and sold him for $4,000 to Bill Lowman, a Washington fisherman fascinated with wild animals.

For a few years, Bobo lived as an official member of the Lowman family. He ate at the dinner table, took a daily bath, wore diapers and children's clothing, and hung around with neighborhood children and his human sisters, Claudia and Sue. Bobo also had hobbies: He liked listening to music (Kate Smith, especially), playing the piano, and teasing Rusty, the family dog.

The gorilla was also a neighborhood and a national tourist attraction. Profiles about Bobo appeared in *Life* magazine, on television, and in newspapers. Bill Cosby even poked fun at Bobo's cushy lifestyle in a comedy routine.

Seattle's Museum of History and Industry (MOHAI) (206) 324-1126 www.seattle .history.org

Life was good for Bobo until, at sixty pounds and two and a half years old, he became literally too big for his kid-size britches. He also became increasingly inquisitive and unintentionally destructive with things like the household furniture. So, heartbroken at losing a family member but understanding that this western lowland gorilla would eventually stand more than six feet tall and tip the scales at more than 500 pounds, the Lowmans agreed to send Bobo to Seattle's Woodland Park Zoo in December 1953.

For the next fifteen years, Bobo was a star attraction at the zoo and was so loved and adored by the community that when he died in February 1968, zoo officials had Bobo stuffed and put on display at Seattle's Museum of History and Industry (MOHAI). His popularity never waned: When the museum put a dusty and worn Bobo in storage, folks kept demanding to see him. A refurbished Bobo was put back on display in the late 1990s, this time surrounded by family memorabilia including photographs, his baby bottle and rattle, and the impossibly small overalls Bobo was dressed in as a "child."

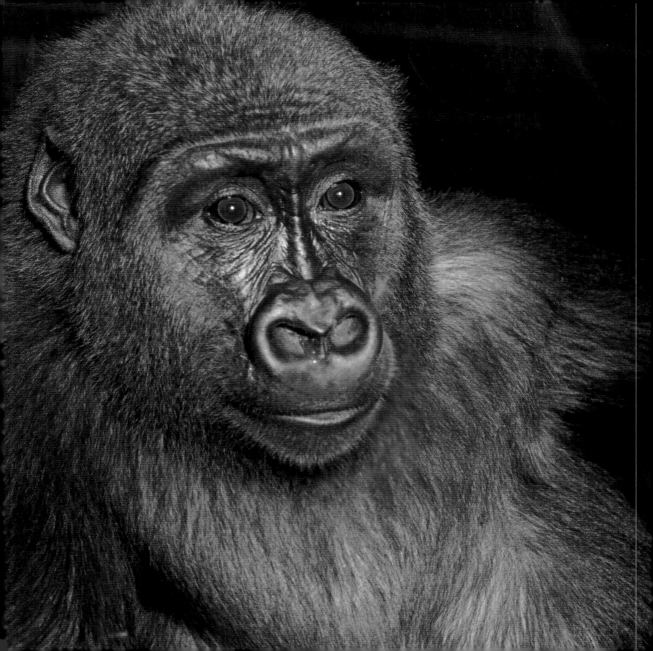

BOEING RED BARN

Today the Boeing Company's sprawling Everett plant cranks out some of the world's largest jets inside the world's largest building (by volume). But the aerospace giant once pieced planes together in a two-story barn in an old shipyard on the Duwamish River.

The Red Barn, as it came to be known, was the main building at the defunct Heath Shipyards, which William E. Boeing purchased for $10 in 1910 so he'd have someplace to build his personal yacht. By 1916 Boeing's Pacific Aero Products Co. was producing seaplanes in the building. In 1917 the company reincorporated as the Boeing Airplane Company and, with a big World War I military contract in hand, shifted to constructing training aircraft for the Navy. Business sagged after the war, and for a few years plant workers were kept busy building square-bottomed speedboats (sea sleds) and furniture. Clients for the furniture included a corset company and a candy store; customers who purchased some of the sea sleds were rumored to include Prohibition-era liquor smugglers.

The Red Barn and Museum of Flight 9404 East Marginal Way South, Seattle (206) 764-5720 www.museum offlight.org

The Boeing Company went on to snag much larger military contracts and developed a successful business designing, producing, and selling passenger aircraft. Soon the company had outgrown the humble wooden barn outfitted with skylights and large multipaned windows. In 1936, aircraft operations were moved to a much larger and more modern plant at Boeing Field, on the opposite side of the Duwamish River. After World War II, the Red Barn was abandoned altogether.

In 1975 the historic barn structure was about to be razed by the Port of Seattle, which had ended up with the aging building. But instead, the Red Barn was sold—this time for just $1—to the Museum of Flight, which barged the structure two miles upriver to its current site. In 1978, in recognition of its status as the oldest aircraft-manufacturing plant in the United States and the fact that it's one of the largest all-wooden factory buildings still around west of the Mississippi River, the Red Barn was placed on the National Register of Historic Places.

Today the restored Red Barn serves as part of the giant Museum of Flight.

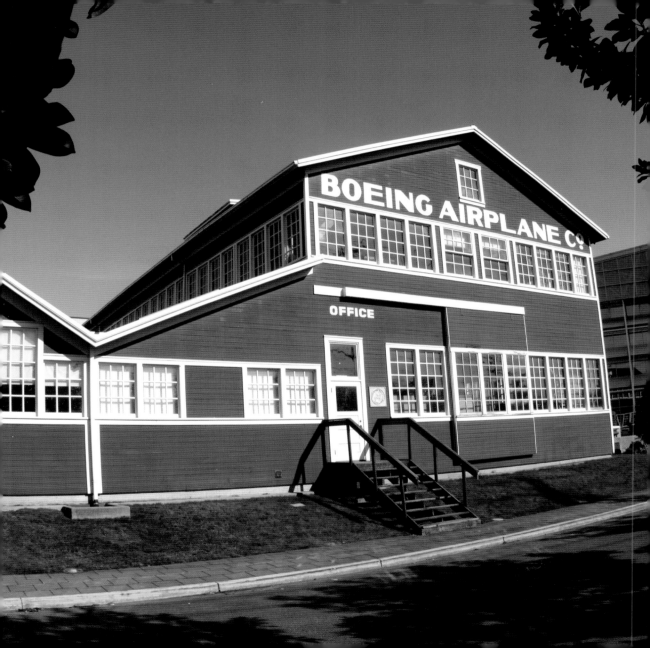

WASHINGTON CHERRIES

Americans eat approximately 2.6 pounds of cherries per person each year. And whether you like your cherries baked in a pie at a picnic, mixed in a sauce spread over salmon, pork, or duck at a restaurant, ladled over ice cream at a café, or just plain "naked" so you can sit on a porch and see who can spit the pits the farthest, it's a good bet the sweet cherries you're eating come from Washington State.

The hot summer days, cool nights, and highly nutrient-rich volcanic soil in and around Yakima, Wenatchee, and other parts of central and eastern Washington create ideal cherry-growing conditions. That's why there are about 36,000 acres of cherry trees in Washington State and why at least 60 percent of the nation's sweet cherry crop is grown here each year. Depending on weather conditions, during an average two-month harvest that averages between four and seven million twenty-pound boxes of fat-free, low-calorie, highly anti-oxidant, and high-fiber cherries each year.

Plenty of the Chelan, Tieton, Bing, Rainier, Lapins, Skeena, and heart-

shaped Sweetheart cherries grown here stay here, but tons of Washington State cherries are shipped out to other states and to more than sixty-two countries. In fact, the delicate, yellow Rainier cherry, with its bright red blush and thin skin, is especially prized in Japan, where perfect fruits command a premium price. Developed in Washington State and named for Mt. Rainier, the Rainier cherry is a cross between Bing and Van, two dark, sweet varieties.

Less dear but still sought-after are Washington's tidy stemless cherries. They're harvested using a machine that separates the cherries from their stems by gently jolting or jostling the tree and collecting the fruit in a soft parachute-like apparatus. That method allows the cherries to be left on the tree a bit longer than handpicked varieties and produces a somewhat sweeter, larger, stemless but not pitless fruit.

There are about 7,000 cherries on an average cherry tree and each tree is capable of producing more than 100 pounds of fruit in a season.

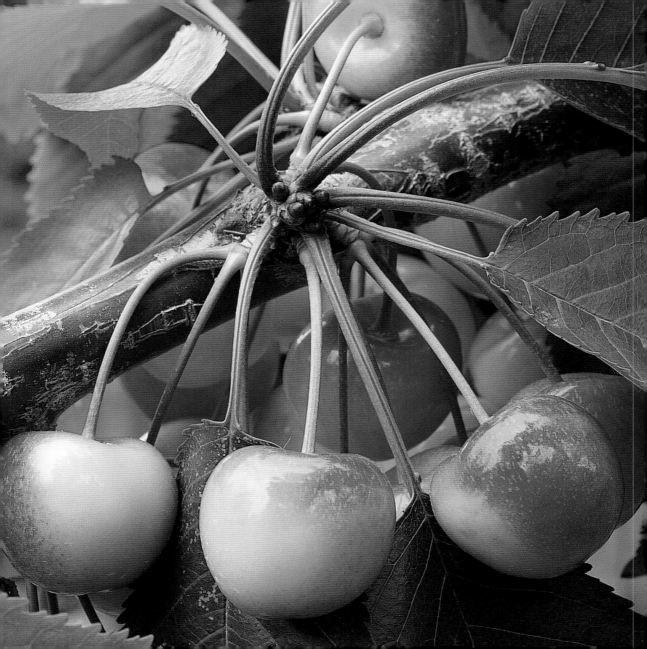

COLUMBIA RIVER

Although its headwaters are in southeastern British Columbia, most of the Columbia River's 1,200-mile route to the Pacific Ocean runs through Washington. The river not only functions as the border between much of Oregon and Washington States, it also serves as a rolling and, at times, roiling part of the state's economic, cultural, and geographic history.

For hundreds of years, Native Americans fished for salmon on this river, most notably at Kettle Falls on the upper Columbia and, in the middle, at Celilo Falls, which was one of the most important and prolific fisheries.

All that began to change, of course, when outsiders arrived. In May 1792, American merchant trader Captain Robert Gray became the first non-Indian to sail his ship into what the Indian people knew as Wimahl (Big River) but which Gray renamed the Columbia, in honor of his ship, the *Columbia Rediviva*. Between 1805 and 1806 the Lewis and Clark Expedition explored and traveled along and beside the river. Trappers, traders, and settlers soon followed.

The Center for Columbia River History www.ccrh.org

Today, the Columbia River, which Lewis and Clark found to be ferocious in some spots and "boiling and whirling" in others, has been tamed. The Grand Coulee, the Bonneville, and many federally and nonfederally built dams now dot the river, interrupting its race to the ocean and making it the top hydroelectric-power-producing river in the country. The river still draws fishers, but now it also lures windsurfers, boaters, kayakers, and kiteboarders, especially in the dramatically scenic, eighty-mile-long Columbia River Gorge National Scenic Area, which reaches from the Cascade Mountain Range to the eastern edge of the Portland metropolitan area.

The Columbia River also has a role in musical history. In May 1941, folksinger Woody Guthrie was hired by the federal government to travel through the Pacific Northwest writing songs to promote the new hydroelectric dams being built on the river. During his one month on the job (salary: $266.66), Guthrie produced twenty-six songs. One of them was "Roll On Columbia, Roll On," a ballad that became Washington's official folk song in 1987.

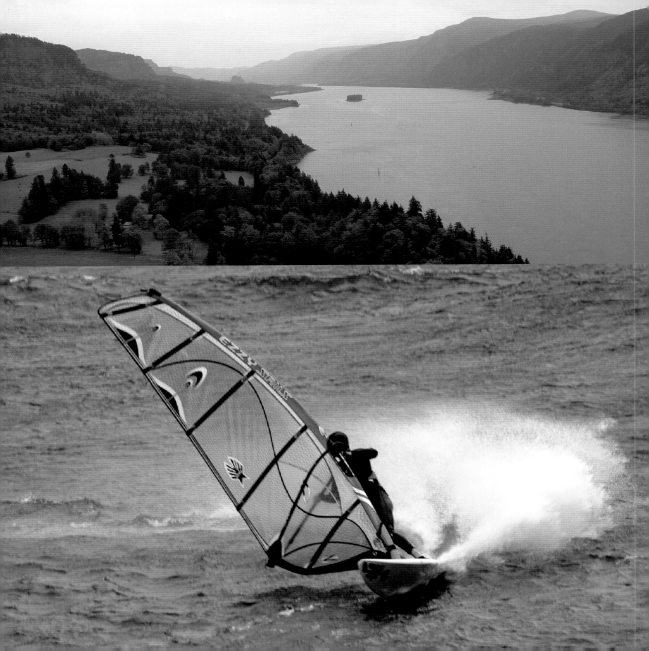

COUGAR GOLD CHEESE

Nearly two pounds of cheese in a can. Sounds strange, but its been an adored, sought-after, and unusually packaged treat in Washington State since the 1940s, when the Creamery on the Washington State University campus in Pullman perfected a novel way to store cheese. Plastic wasn't around yet and traditional wax coverings tended to crack, which allowed stored cheeses to get moldy. So, backed by grants from the U.S. Government and the American Can Company, WSU researchers began toying with ways to pack cheese in tins.

One nutty-flavored cheese they came up with not only aged well in a can, it was also particularly tasty. So tasty, in fact, that in 1948, when the Creamery opened up its retail store, it named that cheese Cougar Gold, in honor of both the WSU mascot and a cheese-project researcher named Dr. N. S. Golding.

Today that cheese is still in production. And still very popular. Every day, ("Cows don't take a day off," says Creamery manager Russ Salvadalena) a

The WSU Creamery and Ferdinand's Ice Cream Shoppe, Food Quality Building at the Washington State University Campus, Pullman. (800) 457-5442 www.wsu.edu/ creamery

student drives a truck seven miles out to WSU's dairy farm and brings back 15,000 gallons of fresh milk. Every year, Creamery workers turn five million pounds of fresh milk products into almost 500,000 pounds of cheese, which is then packed into 250,000 sturdy, thirty-ounce metal cans. Eighty percent of those cans bear a signature yellow-and-white-striped design and are filled with Cougar Gold cheese, that nutty, sharp, white, aged cheddar. The rest are filled with Sweet Basil, Dill Garlic, Hot Pepper, Crimson Fire, and other flavored cheeses, which come in similarly easy-to-spot red-and-white- or blue-and-white-striped cans.

Cougar cheese fans find the foods online, at various Pullman locations, and alongside the almost two dozen Creamery-made ice-cream flavors at Ferdinand's Ice Cream Shoppe, on the WSU campus. That's also where visitors can watch short videos about cheesemaking and watch the Creamery in action from a special observation room.

DICK AND JANE

Look, Jane, look. See Spot run.

From the 1930s through the 1970s, millions of elementary school students in the United States learned to read with the help of simple sentences like this in the charmingly illustrated set of books known as the *Dick and Jane* series.

The short stories revolved around a young boy named Dick, his sister Jane, their chubby-cheeked little sister, Baby (aka Sally), Mother and Father, a cute black-and-white dog named Spot, and a fluffy kitten named Puff.

The vocabulary and plotlines were intentionally simple. Puff would play. Sally was mischievous. Dick and Jane would go or play or jump. In general, though, not much happened.

Still, the series was a big hit with schoolteachers. The books were ubiquitous in schools across this country and others and are fondly remembered by former schoolchildren everywhere. Originally the brainchild of an Indiana elementary schoolteacher named Zerna A. Sharp, many of the *Dick and Jane* books were written and illustrated by two women who spent much of their lives in Washington.

Elizabeth Rider Montgomery Julesberg was a Washington-schooled writer and teacher who went to work for Scott, Foresman & Company not long after the Chicago-based company began publishing the *Dick and Jane* series. As Elizabeth Montgomery, she wrote many of the *Dick and Jane* books and created the name and story line for Dick and Jane's little sister. Baby Sally was based on Montgomery's own daughter, Janet.

Another Washington-schooled artist, Eleanor Campbell, gave Dick and Jane's family their appealing, familiar, and now-classic look. Campbell had been working as a commercial artist in Philadelphia, creating advertisements, magazine covers, and portraits of children, when Zerna Sharp enlisted her as the illustrator for the *Dick and Jane* series. Campbell signed on and used her friends and relatives as models and inspiration for the characters. Her vivid, colorful drawings appeared in all the *Dick and Jane* books until 1956 and, later, her style was copied and retained for the series by other artists.

Cool, Jane and Eleanor, cool.

EXPERIENCE MUSIC PROJECT (EMP)

Before noted architect and classical music fan Frank O. Gehry could design the shrine to modern music that Microsoft's co-founder Paul G. Allen had in mind, Gehry had to learn something about rock 'n' roll. So he stopped in at his local music store and bought some electric guitars. But instead of learning the chords to the Rolling Stones' *19th Nervous Breakdown* or Nirvana's *Smells Like Teen Spirit*, Gehry smashed those guitars into pieces. Then he used the shiny, broken parts to create a model for Seattle's Experience Music Project (EMP) museum building.

The curvaceous building Gehry created sits on the edge of the Seattle Center, just steps from the Space Needle. And although the stainless steel and aluminum EMP building has been an impossible-to-miss part of Seattle's skyline since 2000, the wavy silver, gold, purple, red, and blue–hued structure still strikes a curious and controversial chord with viewers.

Venture beyond the crazy, colorful facade and step inside, and you'll definitely get to experience music. In addi-

The Experience Music Project and Science Fiction Museum 325 5th Avenue North, Seattle (206) 770-2700 www.empsfm.org

tion to a towering sound sculpture made out of 500 guitars, banjos, and other stringed instruments, the EMP houses an interactive Sound Lab that invites visitors to jam with others and create their own music. There's also an ever-changing array of artifacts drawn from an 80,000-piece collection of music memorabilia relating to rock 'n' roll and its influences on jazz, soul, gospel, country, blues, hip-hop, punk, rap, and other genres. The treasures include Bo Diddley's guitar, Janis Joplin's flowered bell-bottoms, and a bevy of objects celebrating iconic musicians and groups with Washington State roots, including Jimi Hendrix, Kurt Cobain, Quincy Jones, and Pearl Jam.

Equally far-out, but in a different way, is the Science Fiction Museum and Hall of Fame, which is tucked inside the EMP. Where the computer-enhanced image of the late R&B legend James Brown once hosted an amusement ride about the history of funk, there are now robots, toy-disintegrator pistols, space suits, and other imagine-another-world artifacts.

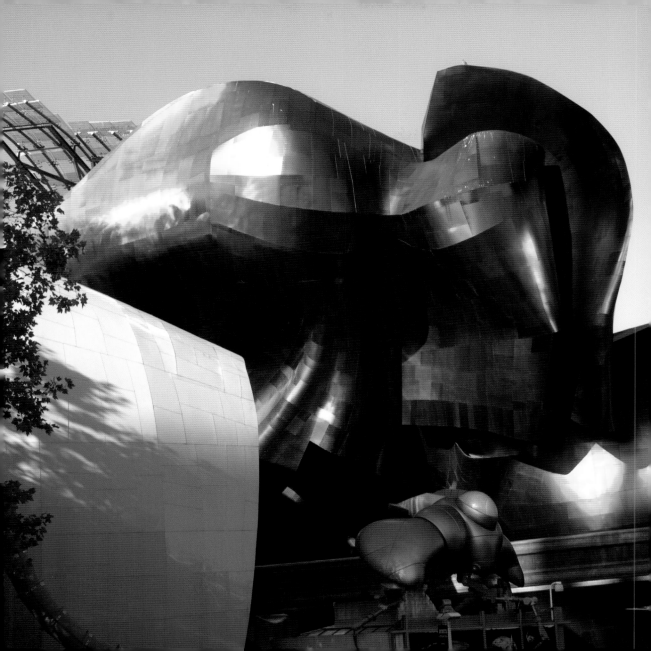

FATHER'S DAY

It's perhaps fitting that the one state named for George—the father of our country—Washington is also the birthplace of the iconic, tie-gifting holiday known as Father's Day, which is celebrated each year on the third Sunday in June.

The idea for the holiday dates back to 1909. That's when twenty-seven-year-old Sonora Louise Smart Dodd of Spokane left a Mother's Day church sermon determined to find a way to honor her dad, William Jackson Smart. He was a tough and determined Civil War veteran who raised a family on his own after his wife died giving birth to their sixth child.

Dodd first floated her dream of a special day honoring her father and dads everywhere during a meeting of area ministers at the local YMCA. By June of the following year, the city of Spokane was celebrating the first "official" Father's Day.

The idea quickly spread to other cities and eventually gained national

Father's Day plaques affixed to a boulder at the YMCA/YWCA 930 North Monroe, Spokane

attention. In 1924, President Calvin Coolidge announced that he was in favor of making Father's Day a recognized holiday. But making it official took years of active lobbying by Dodd and others. In 1956 Congress passed a joint resolution recognizing Father's Day. In 1966, President Lyndon B. Johnson signed the first of what is now an annual presidential proclamation to honor fathers on the third Sunday of June. And in 1972, President Richard Nixon finally made Father's Day an official holiday.

These days, Father's Day is celebrated pretty much everywhere and, according to the folks at Hallmark, it now ranks among the top four card-sending events in the United States. Many of the more than 105 million Father's Day cards purchased surely make their way to Spokane, where two plaques now commemorate the city's tie to the official day for dads. One plaque pays tribute to Sonora Louise Smart Dodd. The other notes the date and the place where Father's Day was founded.

FERRIES

When you think of highways, wide ribbons of blacktop and fast-moving cars and trucks probably come to mind. The Washington State highways are like that, but in the Evergreen State there are also more than 200 miles of marine highway and a fleet of ferries that is the largest in the nation and the third largest in the world.

These boats carry more than twenty-four million riders annually and call on ports in the Puget Sound, the San Juan Islands, the Olympic Peninsula, and Canada's British Columbia province. And while many students, commuters, and commercial shippers use the ferries strictly for transit, a ride on a Washington State Ferry is a popular tourist attraction. Depending on the route and, of course, the weather, a ferry ride offers spectacular views of wooded shorelines, the Seattle skyline, Mount Rainier, and the Cascade and Olympic mountain ranges.

The history of ferry service in Washington State reaches back to the 1890s, when small steamships dubbed the Mosquito Fleet began swarming

Washington State Ferries routes and schedules (206) 464-6400 www.wsdot.wa .gov/ferries

through the Puget Sound linking small communities to each other and to the major transportation hub of Seattle. Larger and more modern boats later replaced individual steamers and, eventually, rail, bridges, and roads eliminated the need for hundreds of routes. By 1929 two private ferry companies remained; by 1935 only one. In 1951, to insure ferry service for the communities that still needed it, the state bought out that remaining ferry company and created what is now Washington State Ferries, with ten routes, twenty terminals, twenty-eight vessels and more than 500 sailings a day.

While the state's Department of Transportation operates the official network of ferries, there are also private ferries serving residents of some of the smaller islands in Puget Sound and a variety of other short-run routes operated by some counties, transit agencies, and at least one Native American tribe. There's even a twenty-minute, 2.8-mile ferry route operated by the Washington Department of Corrections, but only board that ferry as a last resort.

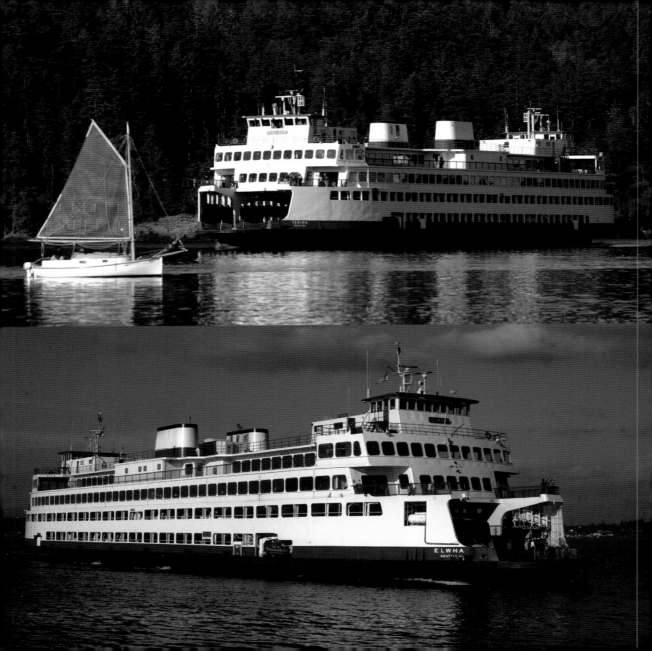

THE FREMONT TROLL

In the classic Scandinavian folk tale *The Three Billy Goats Gruff*, a terrible and terribly ugly troll who, depending on the teller, either has one creepy eye or simply "eyes big as saucers," lives under a bridge, and tries to keep three hungry goats from crossing it.

Things don't end well for that troll, but treacherous, mischievous, thieving trolls show up in other cultures as well. Sometimes they're in the form of dwarfs or giants, but they're always ugly as all get-out, with all manner of magical powers and homes that can be anything from a hill, hut, or cave to entire forests, oceans, and of course, the dark spaces beneath bridges.

All in all, it's generally been a good idea to steer clear of trolls.

In 1990 the folks in Seattle's Fremont neighborhood changed all that.

Building on their reputation of being a bit "out there," the Fremont Arts Council embraced the troll-under-the-bridge tradition and commissioned a team of four local artists

Fremont Troll underneath the north end of the Aurora Avenue Bridge (not the Fremont Bridge) North 36th Street and Fremont Avenue North, Seattle

(Steve Badanes, Will Martin, Donna Walter, and Ross Whitehead) to create a one-eyed, big-nosed, giant shaggy troll sculpture for the Fremont-side footing at the north end of the George Washington Memorial Bridge, known locally as the Aurora Bridge.

Working with rebar and wire, two tons of concrete, and a full-size sacrificial Volkswagen Beetle, the team completed the eighteen-foot-tall Fremont Troll, complete with shiny hubcap-eye, on-site in about seven weeks.

Almost immediately, the Fremont Troll became an iconic and much-loved piece of public art and a whimsical symbol of a community that takes having fun very seriously. In 2005 the Seattle City Council renamed the two-block street in front of the troll Troll Avenue North, in honor of what the mayor called "one of our most famous citizens." Close up, in the daytime at least, the Fremont Troll doesn't look all that scary. And he doesn't complain at all when visitors climb on him to pose for pictures or to poke at his hubcap eye.

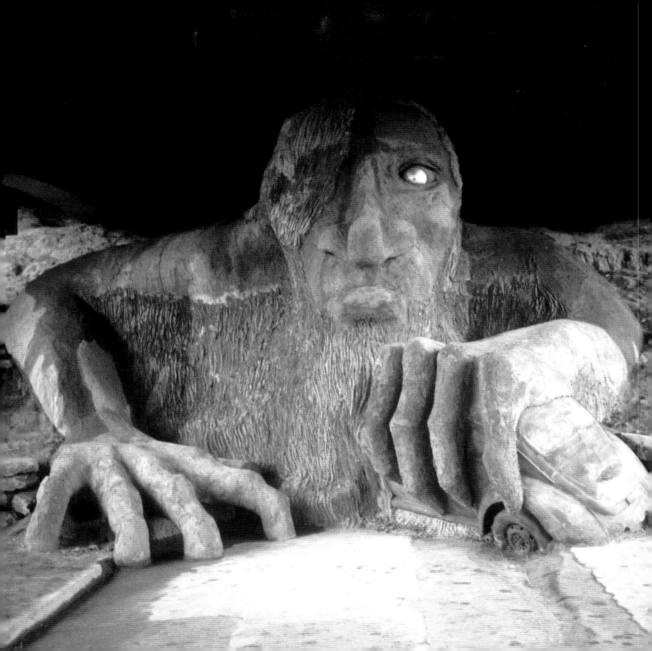

GALLOPING GERTIE

Washington not only holds the record for having the first floating bridge, the state's Puget Sound is also home to the four longest floating bridges in the world. Still, Washington's most iconic bridge is famous worldwide for being a spectacular engineering failure—and the largest man-made structure ever lost at sea.

When it opened, on July 1, 1940, the 5,939-foot-long Tacoma Narrows Bridge was the third-longest suspension bridge in the world. The bridge linked the metropolis of Tacoma with tiny Gig Harbor and other towns on the Kitsap Peninsula that had been culturally, geographically, and economically isolated for generations.

Unfortunately, a serious design flaw in the bridge allowed it to sway and undulate in the wind. In fact, it moved so much that during construction workmen ate lemons to quash queasiness, and when it opened to traffic, drivers reported seeing cars disappear into dips up ahead. Dubbed Galloping Gertie by locals, the bridge became a tourist attraction of sorts, offering a roller-coaster-like ride on windy days for the price of the toll.

Tacoma Narrows Bridge State Route 16 (eight miles west of downtown Tacoma)

Four months later, on November 7, 1940, the fun ended. That morning, the bridge's center span began undulating three to five feet in winds that reached close to forty-six miles per hour. The undulating turned to twisting and the twisting started breaking the bridge apart. Before noon, Galloping Gertie was gone. Besides the bridge, whose dramatic demise was caught on film, there was just one casualty: a cocker spaniel named Tubby whose owner had scrambled out of his car halfway across and managed to crawl to safety.

In 1950, Galloping Gertie was replaced by a safer and even longer bridge, dubbed Sturdy Gertie, and in 2007 yet another bridge opened beside it to accommodate significantly increased regional traffic.

Galloping Gertie is still around. About 2,000 feet of the bridge's original main span are underwater, on the floor of the Tacoma Narrows. In 1992 those remains were placed on the National Register of Historic Places in part to protect her from salvagers, but no doubt to also remind future engineers to double-check their designs.

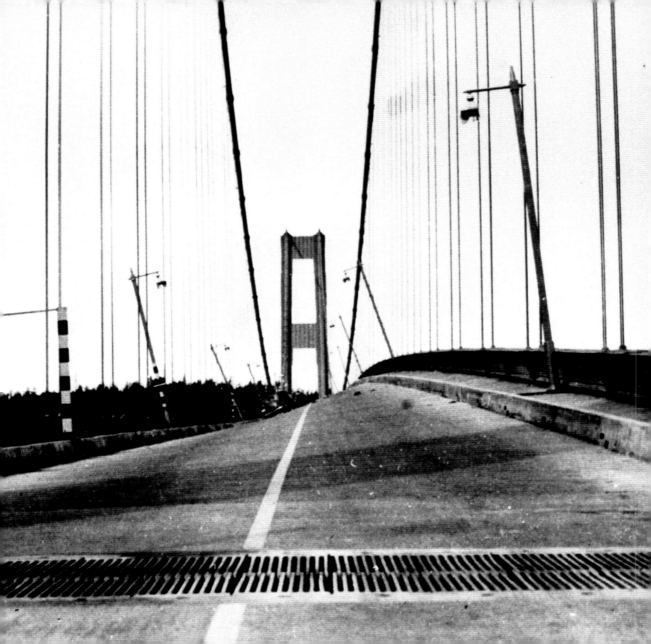

GEODUCKS

The geoduck, pronounced "gooey-duck" (from the Nisqually Indian word meaning "dig deep") is an unusually large and truly strange-looking bivalve found mostly in the waters of Washington's Puget Sound and in parts of Alaska and British Columbia.

www.evergreen
.edu/athletics/
geoduck.htm

These aren't just big clams. These babies are huge and somewhat startling for first-time viewers. Geoducks, the world's largest burrowing clams, average two pounds each (including the shell) but have been known to tip the scales at eight to ten pounds. Over the years, there have even been reports of a few whoppers that have reached thirteen pounds or more. Translated as the "elephant trunk clam" in Chinese and sometimes marketed as "king clams," geoducks have a life span that can top 160 years. They also have a reputation as an aphrodisiac, no doubt due to their large, meaty (some say phallic-looking) necks, or siphons, which can grow to more than three feet long.

Aphrodisiac or not, the clam's meat is a much sought-after delicacy. But

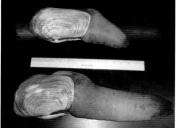

before you can eat it, you'll have to find it. And that can be a challenge. Geoducks spend most of their time buried in mud or sand two to three feet deep. And while there are commercial geoduck harvesters, sport diggers are only permitted to harvest three geoducks a day and can only hunt for them during extreme low tides, which occur less than two dozen times a year. Still, digging for geoducks is a popular sport. Considered by some to be a rite of passage for becoming a true Washingtonian, hunting for geoducks is an art that involves special equipment (only shovels and other hand-operated tools are allowed), skill (you'll need to learn how to spot the telltale surface signs of a geoduck below), a certain amount of luck, persistence, and no fears about getting cold, dirty, and very, very wet.

The geoduck isn't just a tasty seafood delicacy and an unusual attraction at Puget Sound fish markets. The iconic clam is also the official mascot of the Evergreen State College in Olympia, where the athletic teams often sing the "Geoduck Fight Song."

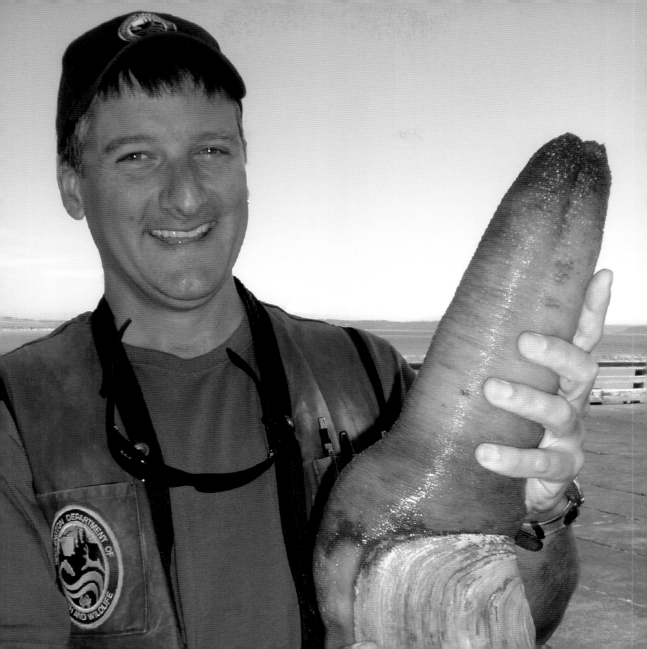

GEORGE, WASHINGTON

That George Washington was one impressive fellow.

While that story about him chopping down the cherry tree turned out to be apocryphal, Washington was in fact the commander in chief of the Continental Army, the first person to sign the Constitution, and, oh yeah, let's not forget, the first president of the United States.

So it's no surprise that old George ended up getting plenty of places named in his honor. There's the nation's capital, of course, and towns named Washington in New Hampshire, Virginia, North Carolina, Georgia, and several other states. And while you might have thought it would have happened much sooner, forty-one states were on board before one named Washington finally joined the union.

That was on November 11, 1889. On July 4, 1957, almost seventy years later, a central Washington businessman named Charles Brown finally went ahead and named the 339-acre town site he'd bought from the U.S. Reclamation Bureau George, Washington. Four years

George, Washington
Exit 149 on Interstate 9 (between Ellensburg and Moses Lake)
www.ci.george .wa.us

later, with a population of 300 people, the town was officially incorporated.

So what's "George Washington" about George, Washington? Well, many of the streets are named after varieties of cherry trees. (In addition to Bing Avenue, for example, there's a street named Montmorency, after the type of cherry tree young George Washington allegedly cut down.) The local grocery is called the Colonial Market. And for years there was a gathering spot in town called Martha's Inn Cafe.

But twice a year, the town really goes "George": On President's Day a party in honor of George Washington features a birthday cake the size of a door. And every July 4, a local women's service group, appropriately named the Georgettes, gets together to bake up yet another "World's Largest Cherry Pie." The pie is made from more than 100 gallons of pie cherries, more than 200 pounds of sugar, and is cooked up in the same eight-foot square, five-inch-deep pan they've been using every July 4 since 1957.

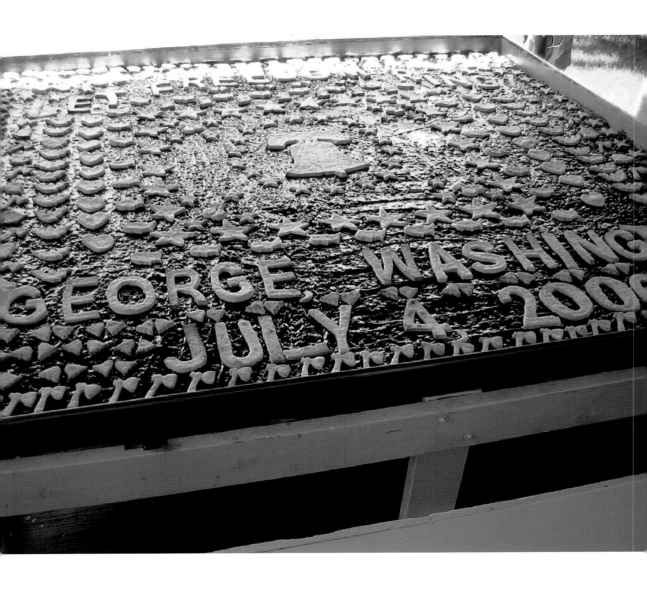

GIANT RADIO FLYER WAGON

Bright and shiny red wagons have been a favorite children's toy—and a great way to tote around younger siblings—since the late 1920s, when Antonio Pasin's Chicago-based Liberty Coaster Wagon Company began using metal-stamping technology to mass-produce toy wagons out of steel. Dubbed the Radio Flyer as a nod to Pasin's fascination with flight, the wagon's name also pays tribute to fellow Italian Guglielmo Marconi, the inventor of radio. Now honored with a spot in the Toy Hall of Fame, Radio Flyer wagons are still manufactured in Chicago, where the World's Largest Wagon (twenty-seven feet long and thirteen feet wide) sits on wheels eight feet in diameter outside company headquarters.

But sadly, Chicago's record-size Red Flyer wagon is off-limits for play. Lucky for us, though, there's another giant red wagon here in Spokane. This one is just a smidge smaller than the one in Chicago. And this one most definitely invites and inspires play. Created by local artist Ken Spiering to celebrate Washington State's Centennial in 1989, the commissioned public artwork is

Giant Radio Flyer Wagon is on the northwest corner of North Stevens and West Spokane Falls Boulevard, Spokane

officially titled *The Childhood Express.* It's an especially apt name for a whimsical, larger-than-life interactive sculpture that welcomes both children and adults to climb up a ladder into the wagon's body and peek out over the wagon walls to see the Spokane River, the circa 1902 clock tower, and the surrounding hundred acres of urban parkland. Then, of course, the real fun is getting to slide down the almost nine-foot-long white handle. Better yet, rides on the giant red wagon's slide are free.

Spokane's Radio Flyer sculpture took about a year to construct and weighs in at twenty-six tons. It's made of steel and reinforced concrete and while not technically the largest red wagon in the world, at twelve feet high, twelve feet wide, and twenty-seven feet long, it is impossible to miss. Look for it in Riverfront Park, the former site of Spokane's world's fair, Expo '74. The wagon is right there next to the historic 1909 Looff Carousel and another much-loved sculpture: Sister Paula Turnbull's steel goat that can "eat" all manner of trash, thanks to a vacuum-operated digestive system.

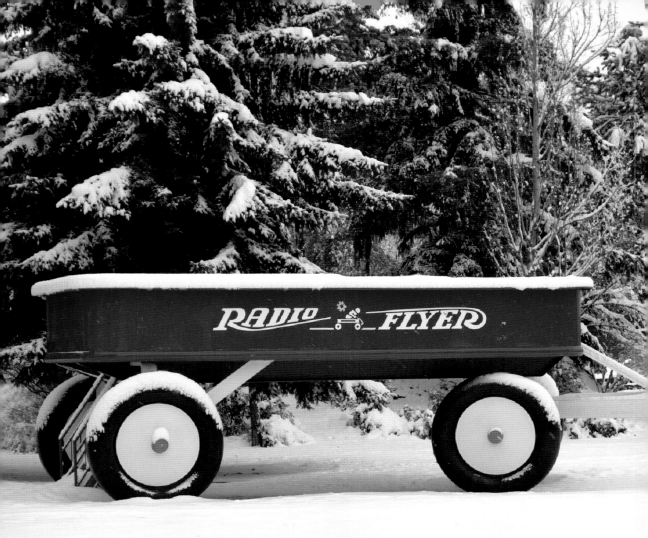

GIANT STUMPS

In the mid- to late-1800s, logging became a way of life in the Pacific Northwest. Vast fortunes were made as timber workers chopped their way through virgin forests filled with trees thousands of years old. Washington's forests were so dense and the trees so numerous that today many historians won't even venture a tree count, preferring instead to toss out phases like "it was a hell of a lot of timber," "a seemingly inexhaustible supply," and "way more timber than people could have possibly used when they started cutting it all down."

No matter, cut it down they did. But back then, the thick, gnarled bases of trees hundreds of feet tall posed a challenge to loggers armed with only handsaws and axes. To find a flat work surface to cut into, loggers would often have to go ten feet up a tree. They'd cut holes in the tree, stick boards in the holes, and then stand on those boards while cutting down the tree.

The trees they toppled were dragged out the woods, trucked to sawmills, and turned into lumber. The stumps were

Stillaguamish Valley Pioneer Museum
(360) 435-7289
www.stilly museum.org

The walk-through stump is at the Smokey Point rest area, Interstate 5 north (near Arlington).

burned or left behind. And now that an estimated 95 percent of the old-growth trees have been logged, we have only fading photographs and some of those giant stumps to remind us of how enormous those old growth trees really were.

If you hike, you'll come across some of the stumps rotting in the woods. A few stumps have even been transformed into community souvenirs. In Arlington, a twenty-foot-tall stump house from the 1930s sits in the parking lot of a museum. Eighteen feet across, with a wide doorway and an upper level, this stump served as everything from a storage shed to a stage where politicians addressed local crowds. Up the road a bit, in a highway rest area, there's an even bigger and more famous stump. This one has an archway in the center that's big enough to drive a car through. And in 1939, Norway's Crown prince Olav and Princess Martha had their picture taken doing just that. These days, though, the stump is a walk-through attraction that serves as an unusual and iconic link to Washington's woody past.

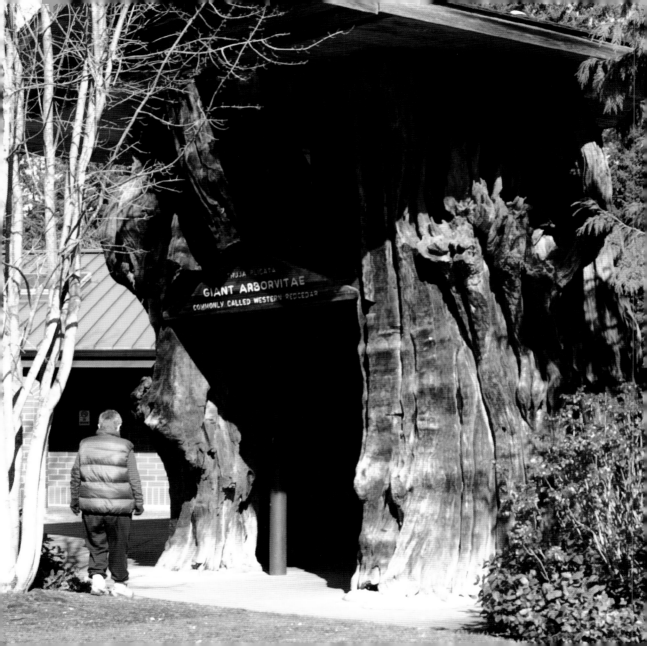

GRAND COULEE DAM

No doubt about it: Grand Coulee Dam is *grand*.

It stretches across the Columbia River, it's twice as high as Niagara Falls, it's just shy of a mile long, and it's the largest concrete structure in the United States. Lake Roosevelt, the reservoir behind the dam, is 150 miles long and it has 630 miles of shoreline. Grand, right?

The dam is also dense: It's made of almost twelve million cubic yards of concrete; enough concrete, engineers say, to build a four-foot-wide, four-inch-thick sidewalk around the equator. Twice.

The dam is a good provider: It helps irrigate more than 600,000 acres of farmland in the otherwise-dry Columbia River Basin, and it's the largest producer of hydroelectric power in the United States, sending electricity to at least eleven states.

But it's also a heartbreaker. Construction of the dam claimed lives, communities, and a way of life. While building the dam, seventy-seven men died from drowning and blasting or from construction-site vehicle accidents. (It's been said that some men were

Grand Coulee Dam
Highway 155
(90 miles west of Spokane)
(509) 633-9265
www.grandcouleedam.org

buried alive in the dam in the rush to pour concrete, but officials say it's just a rumor.) Close to a dozen rural communities were displaced by the dam, forcing families and farms to relocate. And by blocking the wild salmon runs on the upper Columbia and flooding ancient Native American burial land and fishing grounds, the dam caused irreparable economic and cultural loss to area tribes.

Still, when all the concrete work was completed in August 1941, after an eight-year, round-the-clock effort by thousands of Great Depression–era workers, the Grand Coulee Dam was considered to be the Eighth Wonder of the World. Now one of eleven major dams on the U.S. side of the Columbia River, the Grand Coulee Dam is still the most impressive, inside and out. Each year, thousands of visitors take the glass-fronted elevator ride that descends 465 feet (at a thrilling forty-five-degree incline) into the dam's third power plant for a look around. And, on summer nights, the outside of the dam is used as the backdrop for what might be the world's largest laser-light show.

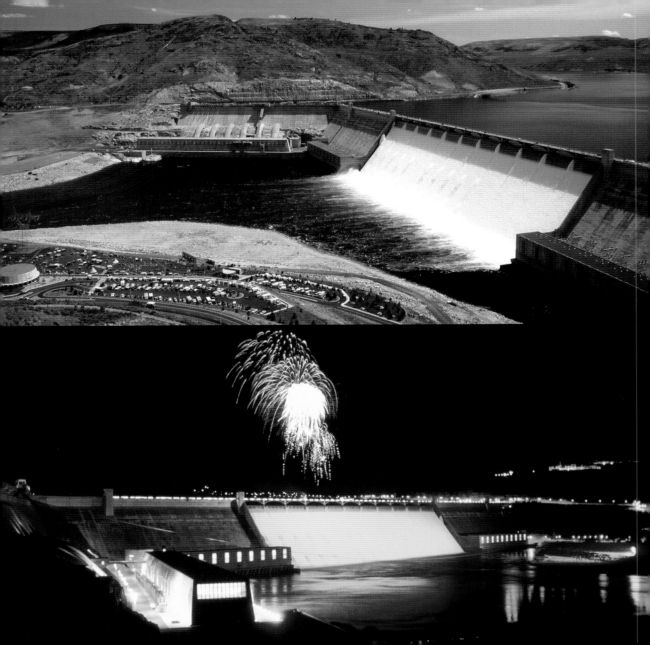

HAT 'N' BOOTS

If you had a car back around 1907, getting around was easy. The challenge was filling up the tank. Lacking service stations, motorists would tote five-gallon cans of gas home from the general store. That all changed when Seattle-based oil salesman John McLean opened what is believed to be the world's first gasoline service station. He bought land next to an oil distribution depot, filled a tank on his property with oil piped over from the main storage tank, and hooked up a hose so he could pump gas right into the gas tank on a car.

Today, of course, there are gas stations everywhere. And they all look pretty much alike. But back in the mid-1950s, Seattle had a cowboy-themed service station that was impossible to miss. Designed by Lewis H. Nasmyth and engineered by Bruce Olsen, the Hat 'n' Boots Premium Tex gas station had an office shaped like a giant cowboy hat measuring forty-four feet across. Nine pump islands stood beside a pair of twenty-two-foot-tall cowboy boots, which served as restrooms.

Made out of steel beams, chicken wire, and loads of plaster, this high-

Hat 'n' Boots in Oxbow Park 6400 block of Carleton Avenue South, Seattle www.hatnboots .org

octane roadside attraction was supposed to mark the entryway to a 200-store shopping center. That retail project went bust, but Hat 'n' Boots kept right on pumping from its prime spot along busy Highway 99. In its heyday, the Hat 'n' Boots service station was one of the highest-grossing stations in the state, and legend has it that Elvis Presley even pulled up one day in 1963 to fill up the tank on his Cadillac when in town filming *It Happened at the World's Fair.*

Unfortunately, the Hat 'n' Boots gas station closed down in 1988 and the eye-catching attraction lost its paint and its luster. Demolition was averted only when neighborhood residents and local celebrities joined forces to save the much-loved, inoperable icon. At one point, boosters even held a demonstration featuring protesters wearing all manner of hats 'n' boots.

The structures were saved and in 2003 the quirky landmark was trucked to a new home in a park in Seattle's Georgetown neighborhood. So far, the boots have been lovingly restored; repairing and reblocking that giant hat is next.

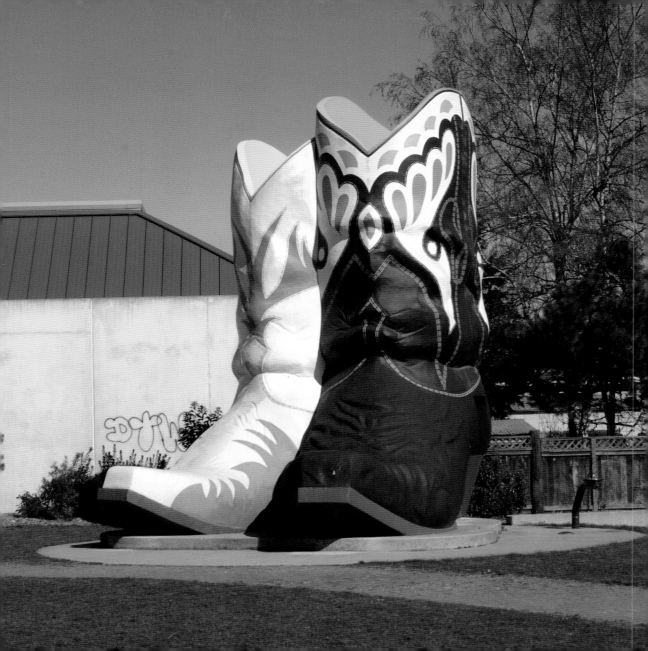

HYDROPLANES

Hydroplanes are motorboats with only one purpose in life: going as fast as possible. Loud, sleek, and light-weight, these marine hot rods are built for speed and designed to race across the water suspended on a cushion of air, with only a small part of their propellers, rudders, and sponsons (pontoon-like supports) touching the water.

The extreme water sport of hydro-plane racing has a long history as a spectator sport in Washington. Motor-boat races were featured at Seattle's first world's fair, the 1909 Alaska Yukon Pacific Exposition. And from the late 1920s until the mid-1980s, to the delight of racing fans and the chagrin of noise-sensitive neighbors, powerboat rac-ing was a regular event at Seattle's urban Green Lake Park.

Seattle's love of hydroplaning shifted into high gear around 1950. Hydroplane historian David Wil-liams says that's when the bright red hydroplane Slo-mo-shun IV, piloted by Seattle car dealer Stan Sayres, shat-tered the world speed record on water

Hydroplane and Raceboat Museum, Kent (206) 764-9453 www.thunder boats.org

by zipping along at 160.3235 mph on a course at Seattle's Lake Washington. When Slo-mo-shun IV won the sport's coveted Gold Cup trophy in Detroit and brought the races home to Seattle, "hydro fever" morphed into a full-fledged sports mania. Hydroplane races have been taking place in the city every year since.

Hydroplanes now compete at speeds that often exceed 200 mph. And over the years dozens of powerboat records have been broken on Lake Washington, where trophy-winning boats with names like Miss Thriftway, Miss Budweiser, and Miss Bardhahl (aka the Green Dragon) have thrilled tens of thousands of fans during the races that cap Seattle's month-long summer Seafair celebration. Since 1966, the high-adrenaline sport known for rooster tails (huge plumes of water), collisions, and spinouts has also been celebrated in the Columbia River towns of Kennewick, Pasco, and Richland (the Tri-Cities) at the annual Columbia Cup Unlimited Hydroplane Races held in Columbia Park.

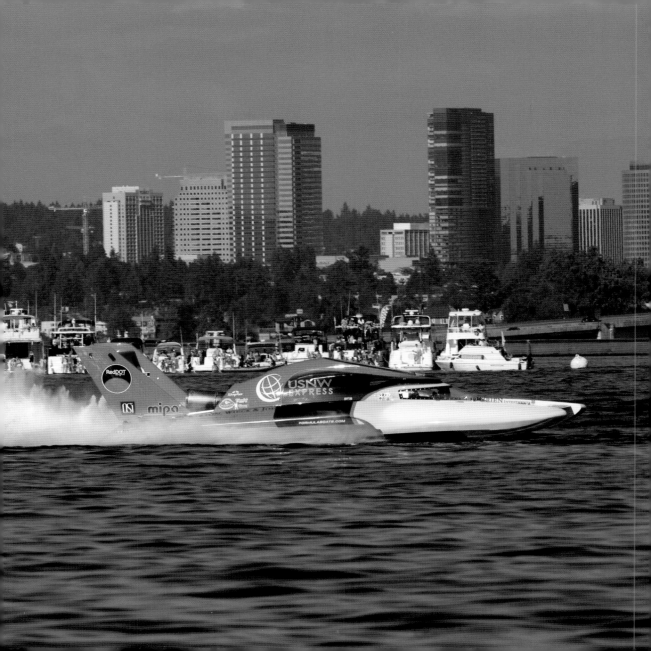

IVAR'S SEAFOOD RESTAURANTS

Seattle's first waterfront aquarium opened in 1938, on Pier 54. The creation of Seattle folksinger and eccentric entrepreneur Ivar Haglund, the aquarium featured an on-site fish-and-chips bar offering visitors both something to nibble on and something to spend a bit more cash on after seeing Patsy the Seal, Barney the Barnacle, Oscar the Octopus, and other marine attractions.

Fresh shrimp and oyster cocktails, hot clam chowder, and ten-cent fish-and-chips entrées were extremely popular with tourists. Perhaps a little too popular: The owner of the restaurant already on the pier lost lots of business and convinced the pier's landlord to have Haglund shut down his seafood shack. No problem. Come 1946, Haglund opened his own restaurant, Ivar's Acres of Clams, on the very site of his by-then out-of-business competitor.

Haglund set out to promote both the aquarium and the dining venue with a string of wacky antics that included octopus wrestling, clam-eating contests, and an infamous publicity stunt in which the restaurant's "f(l)ounder"

www.ivars.net

rushed out the door with a giant spoon and a stack of pancakes when a railroad tank-car spilled its load of sweet, sticky syrup near the restaurant's front door. Conveniently, newspaper photographers were on the scene as well.

The aquarium closed down in 1956, but the antics and the expansion of the dining "empire" continued. Haglund eventually bought Pier 54 and declared the area outside Ivar's Acres of Clams a sanctuary for all seagulls and all seagull-feeding fans being shooed away by a neighboring business.

Today, in addition to Ivar's seafood and fish bars throughout the northwest, there are several full-service restaurants, including the iconic-on-its-own Ivar's Salmon House on Seattle's Lake Union. Designed to resemble a Northwest Indian longhouse, the restaurant houses a collection of museum-quality Native American artworks and artifacts. Most notable are the dugout canoes dating from the early 1900s, a thirty-five-foot-tall "Welcoming Man" totem pole weighing in at 4,000 pounds, and a giant pair of well-preserved "whale-makers" (whale phalli) that are hidden in plain sight.

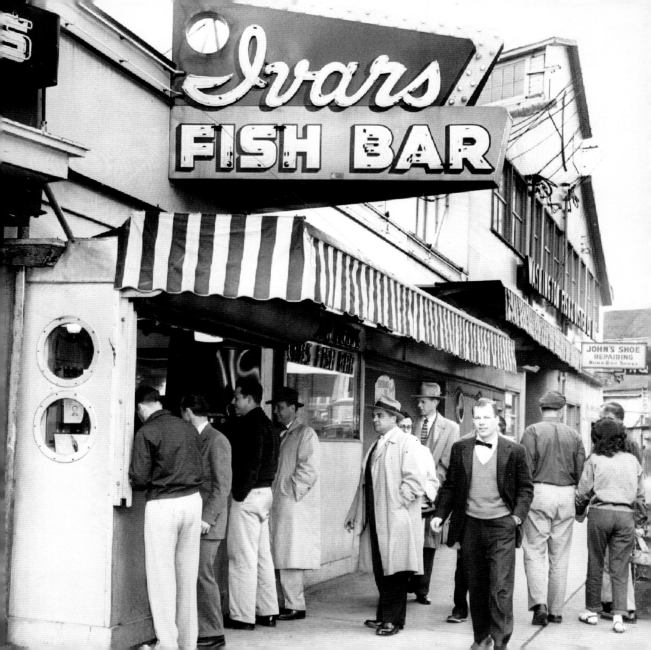

JOLLY GREEN GIANT

The "Ho-Ho-Ho" Jolly Green Giant of commercials may officially hail from Minnesota, but for years the folks in Dayton were sure that their historic Washington town was the true year-round home of the big guy in the green leafy tunic.

No wonder: For about seventy years, starting back in the 1930s, Dayton was the home of the world's largest asparagus cannery. Most all canned asparagus with the Green Giant label—about thirty-six million cans a year—was processed here. The cannery was the town's major employer and for years the giant was the town's unofficial mascot. His image appeared on everything from jackets, hats, and cookie jars to dolls, clocks, and radios.

A green giant also greeted visitors from a hillside at the edge of town.

Back in the 1970s, a proud local asparagus farmer began outlining and heavily fertilizing a spot above his fields to form the shape of the Jolly Green Giant. The hillside handiwork could be seen from the fields, from the highway, and from the sky. As the season pro-

Jolly Green Giant U.S. Highway 12, Dayton (about a mile west of downtown) (800) 882-6299 www.historic dayton.com

gressed, the giant would get greener and easier to make out, but when the rains stopped, the giant would dry out, get blurry, and disappear.

In the early 1990s, a group of cannery workers, farmers, and community volunteers joined forces to make a bigger and better giant. Their green guy is as big as a football field and made of several thousand green-and-white flat cement patio blocks that have stayed put and remained visible to passersby year-round.

Unfortunately, Dayton's cannery business has not stayed put. Although Washington State farmers still grow fifty-three million pounds of asparagus each year, in 2005 the entire asparagus canning operation was moved to Peru.

Dayton lost many good-paying seasonal and full-time jobs. Area farmers lost a steady buyer. But the town didn't lose its giant.

While some local residents would just as soon scrape that giant off the hill, he's still there. He may be a bit faded and fuzzy, but for now he serves as landscaped link to a lush, green past.

LONG BEACH

As touristy beach towns go, Long Beach, on Washington's Long Beach Peninsula, has the standard attractions: fast-food restaurants, stores selling fudge, salt-water taffy and ice-cream, go-karts, arcades and, of course, sand. But this beach town has a few iconic extras.

There's the beach itself. While the claim to being the world's longest beach has been challenged, the twenty-eight-mile beach is certainly the longest beach in this country and most certainly the country's longest drivable beach. If you can keep your car from getting stuck in the sand, head into town and you'll find two other intriguing, offbeat, and infamous Washington icons: the Giant Frying Pan and Jake the Alligator Man.

The giant cast-iron frying pan was forged back in the 1940s when coastal towns like this needed some sizzle. The original ten-by-twenty-foot pan weighed in at 1,300 pounds (the modern-day pan in the town's pocket park is a bit smaller) and was first used at the 1941 Razor Clam Festival to fry the world's largest

Long Beach
State Route 103
on the Long
Beach Peninsula
(360) 642-2188
www.funbeach
.com

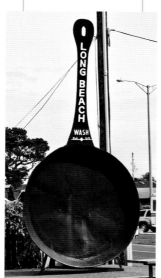

razor clam fritter. In a bit of early cross-promotion genius, the pan was once trucked to Winlock during that town's Egg Day festivities, where it was used to prepare giant omelets for the crowd.

Big is good, but bizarre may be better. The oddity-filled Marsh's Free Museum in Long Beach is home to Jake, who appears to be half man and half amphibian. In true sideshow attraction fashion, the mummified Jake the Alligator Man appears to have the leathery head and torso of a shrunken human and the scaly lower body and tail of a small alligator. No one knows exactly how Jake got that way or where he came from, only that he was purchased from an antiques dealer in 1967 and has been smiling at visitors with his tiny sharpened teeth ever since.

Jake reached icon status long before 1993, when his picture was splashed across the front page of a popular supermarket tabloid. But now that he's got a worldwide cult following, locals say Jake's smile seems even toothier. And a little scarier.

MARYHILL MUSEUM AND STONEHENGE MONUMENT

Sam Hill was a successful Northwest businessman and entrepreneur who had a hand in developing the Columbia Gorge Highway (on the lush Oregon side of the Columbia River), the Peace Arch (on the Washington/ Canada border), and a variety of other noteworthy commercial and civic Pacific Northwest projects.

Some projects didn't turn out quite like Hill planned. In 1907 he bought more than 5,000 acres of land on the arid Washington side of the Columbia River and announced plans to build a Quaker farming community to be named Maryhill, after his wife and daughter. The project failed, in part due to irrigation challenges and the strong Columbia Gorge winds, and Hill lost interest in completing the unusual three-story, poured-concrete mansion he'd commissioned for his own home there.

Then Loie Fuller swept in. The flamboyant pioneer of modern dance, known in Paris as the Fairy of Light, convinced Hill to turn his empty ranch house into an art museum. Fuller also persuaded her friend, Queen Marie of

Maryhill Museum of Art
State Route 14 (overlooking the Columbia River), west of U.S. Highway 97 and across the Biggs Rapids–Sam Hill Bridge from Interstate 84
(509) 773-3733
www.maryhill.org

Romania (the granddaughter of Great Britain's Queen Victoria), to come to Washington for the museum's dedication. The queen accepted the invitation but, after a much-publicized thirty-seven-day train trip across the United States in 1926, the queen and her entourage arrived at Maryhill only to find a crowd of more than 2,000 well-wishers—and an unfinished, empty building. She gave her blessing anyway.

The museum finally opened in 1940, seven years after Sam Hill's death, and today the Maryhill Museum of Art is an iconic structure on the National Register of Historic Places. Its eclectic collection includes some of Queen Marie's royal artifacts, sculptures by French master Auguste Rodin, antique chess sets, and rare Native American baskets and beadwork.

Down the road from the museum, on the original Maryhill town site, there's another iconic structure: a full-size, though not totally exact, replica of England's Neolithic Stonehenge. Sam Hill built it to honor local soldiers lost in World War I.

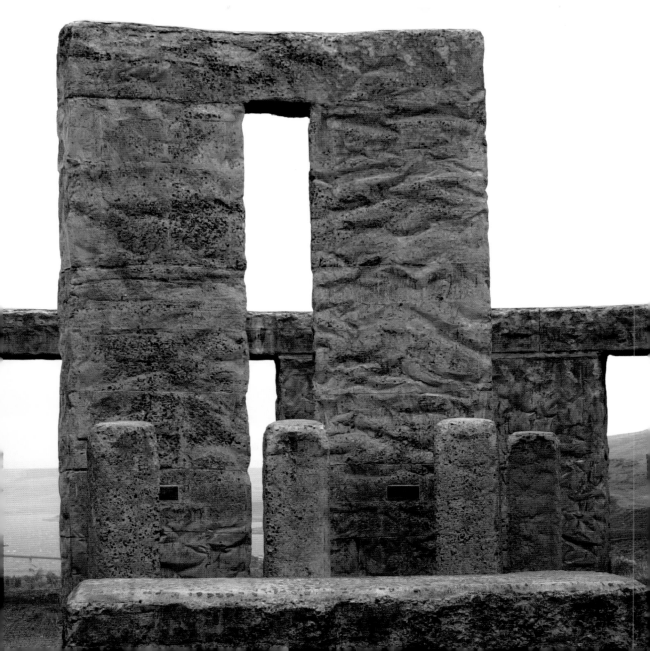

MICROSOFT

Do you have a personal computer in your home, at your office, or at school? If you do, then chances are that, like the nearly two billion PCs around the world, the computer relies on an operating system and software applications created by the Redmond, Washington–based Microsoft Corporation, one of the most important technological businesses in the world.

The company was co-founded by Bill Gates (William Henry Gates III) and Paul Allen in 1975. These geeky-but-brilliant guys first became infatuated with a newfangled thing called the computer in the late 1960s, at a private prep school in Seattle. Hard to believe now, but back then computers were room-size machines that were incredibly complicated and expensive to run. By special arrangement, the prep-school students could access the computers of a few local corporations, but after hacking those systems one too many times, that privilege was rescinded. By then though, Gates, Allen, and their friends were dealing directly with the computer companies,

*Microsoft Visitor Center
15010 NE
36th Street,
Redmond.
(425) 703-6214
www.microsoft
.com/about/
company
information/
visitorcenter*

trading programming skills for unlimited playtime on the computers.

In the mid-1970s, smaller "microcomputers" were introduced. And that's when Gates and Allen, by then computer-obsessed young men, turned their energies to developing software programs for machines they believed might one day become commonplace in homes and businesses. Their instincts were right: Their company, Microsoft (originally Micro-soft) developed a computer operating system (MS-DOS) that was licensed to IBM and then to other companies selling personal computers. Microsoft expanded its offerings, and in 1987, just a year after going public, the company rolled out its now-ubiquitous Windows operating system. Soon after, Microsoft Office software applications hit the market. Today Microsoft products, including the popular Internet Explorer Web browser, dominate the PC industry. At the end of 2008, the company employed more than 95,000 people; more than 40,000 of those workers live and work in Washington's Puget Sound.

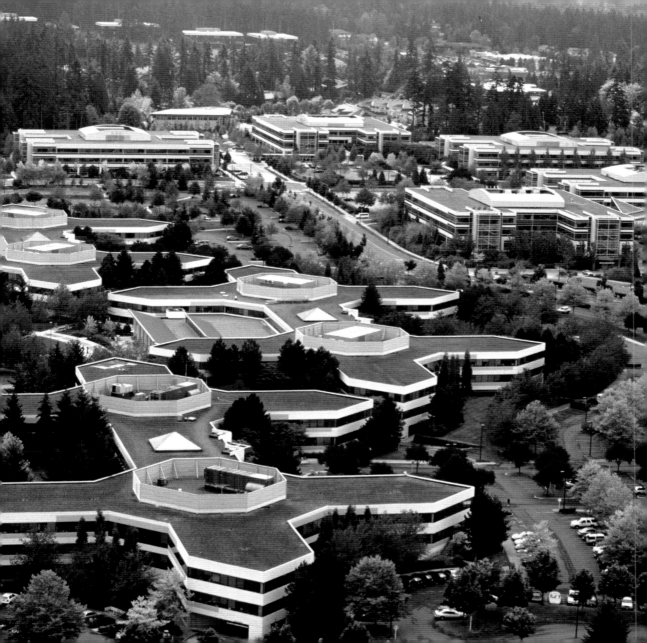

MOUNT RAINIER
AND MOUNT ST. HELENS

Washington is blessed with some pretty impressive mountains, including Mount Adams, Glacier Peak, Mount Baker, and Mount Olympus. But when it comes to picking the state's peak peaks, two mountains stand out as icons: Mount Rainier, the state's tallest mountain, and Mount St. Helens, the state's most infamous mountain.

That's Mount Rainier, snowcapped as always, on the state quarter. At 14,410 feet above sea level, it's a mile and a half taller than any nearby mountain and holds a prominent spot in a wide swath of the western Washington landscape. Part of the more-than-235,000-acre Mount Rainier National Park, the mountain was known to local Native American tribes as Tahoma before 1792, when Captain George Vancouver renamed it Rainier in honor of his friend, Rear Admiral Peter Rainier.

The admiral never visited Mount Rainer, but each year more than 10,000 people try to climb it. And even with guides and experience, more than half of those summit-seekers surrender to weather, altitude sickness, or unexpected

*Mount Rainier
National Park
(360) 569-2211
www.nps.gov/
mora*

*Mount St. Helens
National Volcanic
Monument
(360) 449-7800
www.fs.fed.us/
gpnf/mshnvm*

changes in the climbing conditions on the glacier-clad mountain.

Like Mount St. Helens, Mount Rainier is an active volcano. But unlike Mount Rainier, which last erupted more than 100 years ago, Mount St. Helens has had recent and very devastating volcanic activity. On May 18, 1980, the picturesque mountain once known as the "Fuji of America" because it resembled Japan's symmetrical snow-capped volcano, experienced an explosive eruption. The blast blew ash more than fifteen miles into the air and triggered the largest landslide in recorded history. Racing mudflows and rock debris swept downhill, blocking parts of the Columbia River, more than seventy miles away. When the nine-hour eruption was over, fifty-seven people and countless animals were dead, more than 230 square miles of forests were flattened, numerous homes, bridges, roads, rivers, and highways were destroyed, and 1,000 feet of elevation were blown off the mountain's northern face. Today the mountain and recovering surrounding environment are part of the Mount St. Helens National Volcanic Monument.

NORDSTROM

These days Nordstrom is known nationwide as an upscale department store chain that hires accomplished pianists to tickle the keys and entertain shoppers in a majority of its stores. Over the years, the musical shopping amenity and the generous, in some cases legendary, approach to customer service and returns has brought the company loads of attention and legions of fans. And while Nordstrom Inc. now operates 171 stores in twenty-eight states, the company is inextricably linked to Washington State and Seattle.

In 1901, John W. Nordstrom sold his share of an Alaskan gold-mining claim, returned to Seattle, and opened a downtown shoe store with a friend. Over the years, that single shoe store grew into a chain of eight shoe stores, and in 1960 Nordstrom's Seattle shoe store was the largest shoe store in the country. In 1963, the company acquired women's fashion retailer Best Apparel, and by the late 1960s Nordstrom stores in Washington and Oregon were offering customers fashionable clothing and accessories for men, women, and children. The successful chain began

Nordstrom Flagship Store 500 Pine Street, between Fifth and Sixth Avenues, Seattle www.nordstrom .com

opening stores nationwide in the late 1980s and was soon the largest fashion specialty retailer in the country.

Not bad for a shop that began selling shoes.

This story of retail expansion wouldn't be particularly noteworthy were it not for the fact that as the company grew, it maintained its Nordstrom family connection and its founder's commitment to exceptional and, in a few noteworthy cases, over-the-top customer service. One classic and often-repeated example of that service is considered by some to be an urban legend, although company officials insist it's true. The story goes that back in 1975—not long after Nordstrom bought out a general dry-goods store in Alaska—a customer who hadn't noticed the ownership change showed up intent on returning a set of tires. Nordstrom stores didn't sell tires, but that didn't faze a determined-to-please employee who went ahead and accepted the return. Today, while shoppers will find clothing, accessories, cosmetics, jewelry, bedding, housewares and, of course, shoes in Nordstrom stores nationwide, the inventory still does not include tires.

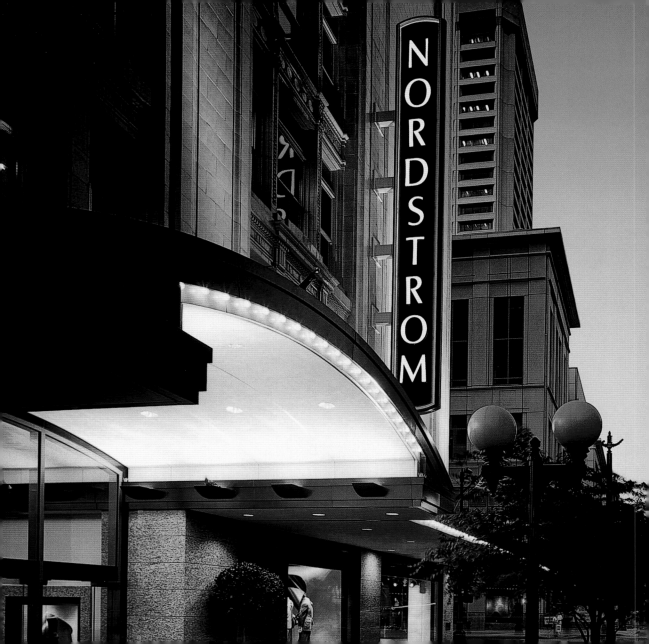

OLYMPIA OYSTERS

Early settlers in western Washington encountered giant trees in the woods and tiny, sweet oysters barely two inches across in the tidal mudflats in the bays. Local Indian tribes had been feasting on these plentiful native Northwest oysters for centuries and, at times, trading them with early explorers. But a major oyster-export business sparked by the 1849 California Gold Rush almost wiped out what became known as the Olympia oyster.

Oysters of all types were a popular treat for the money-flush gold miners and fortune seekers who descended on San Francisco during the early days of the Gold Rush. In fact, the bivalves were in such high demand that the oyster beds in San Francisco Bay were quickly overharvested and emptied out. Oysters were still plentiful up north in Washington, however, and in 1851 ships loaded with bushels of the tasty, slow-growing oysters from Shoalwater (now Willapa) Bay in the southwest part of the state began making regular trips south. For a while the oyster craze made the town of Oysterville, on the Long Beach Pen-

Willapa Bay Oyster Interpretive Center
Long Beach Peninsula,
Nahcotta
(360) 665-4547
www.portof peninsula.org/ oysterhouse.html

insula, the wealthiest (and some say the wildest) town in Washington, but by the 1870s continuous harvesting had decimated the natural oyster beds in Willapa Bay and Puget Sound as well. Well-to-do West coast diners could still order oysters, but they had to make do with oysters shipped cross-country from the east coast by train.

Luckily, Washington's native Olympia oyster didn't disappear entirely. But it hasn't been easy: Over the years the silver-dollar-size Olympia oyster has had to struggle not only with overharvesting but also water pollution and, in the late 1920s, the introduction of the larger, heartier, and faster-growing Pacific or Japanese oyster into Washington waters. Today, Miyagi, Kumamoto, Hiroshima, and other varieties of the Pacific oysters farmed here make up almost 99 percent of the commercial and recreational oyster harvest on the west coast. But thanks to restoration projects and a determination by some groups to keep the native species alive, the Olympia oyster is making a slow and very sweet-tasting comeback.

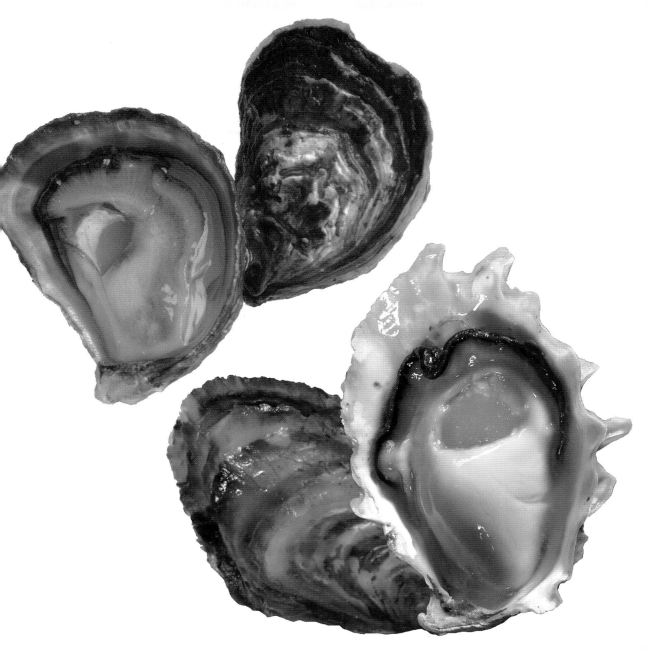

INTERNATIONAL PEACE ARCH

Each year, close to two million cars and more than two million people (most of them in those cars, but a few thousand on foot) cross the border between the United States and Canada at Blaine, a lovely northwest Washington town thirty-five miles south of Vancouver, British Columbia, and 110 miles north of Seattle. Beyond the going-through-customs-in-your-car experience, what most travelers remember about this spot is the impressive and iconic International Peace Arch. The sixty-seven-foot-tall white concrete and reinforced steel structure straddles the international boundary, with one foot in Blaine, Washington and the other in Surrey, British Columbia.

The Arch (originally called the Peace Portal) was a pet project of noted Washington industrialist Sam Hill, and it commemorates the centennial of the signing of the Treaty of Ghent in 1814. That pact marked the end of the War of 1812, a conflict between the United States and the British Empire that played out on the U.S.–Canadian border. Back then, the idea of lasting peace was a popular idea: When the monument was

The International Peace Arch Interstate 5, at the U.S.–Canadian border

Blaine Visitor Information Center (800) 624-3555 www.parks.wa .gov

finally built and dedicated on September 6, 1921, more than ten thousand people showed up to celebrate. Attendees included Canada's Miss Britannia as well as Miss Columbia from the United States. U.S. President Warren G. Harding could not be there in person, but he did send an official greeting that called the arch a "temple of peace."

Today that "temple of peace" not only stands as a symbol of international friendship, it's also one of the few structures in the world listed on the historic registers of two countries and it is surrounded by more than forty acres of parkland that, like the Peace Arch, straddles the United States and Canada. (The U.S. side is called Peace Arch State Park; in Canada it's the Peace Arch Provincial Park. No passports are needed to wander between the parks.) The playground, picnic areas, and meticulously tended-to gardens welcome more than 500,000 visitors a year, and each spring, on the second Sunday in June, up to 20,000 people show up to take part in a "Hands Across the Border" celebration that includes a parade through the arch and across the border.

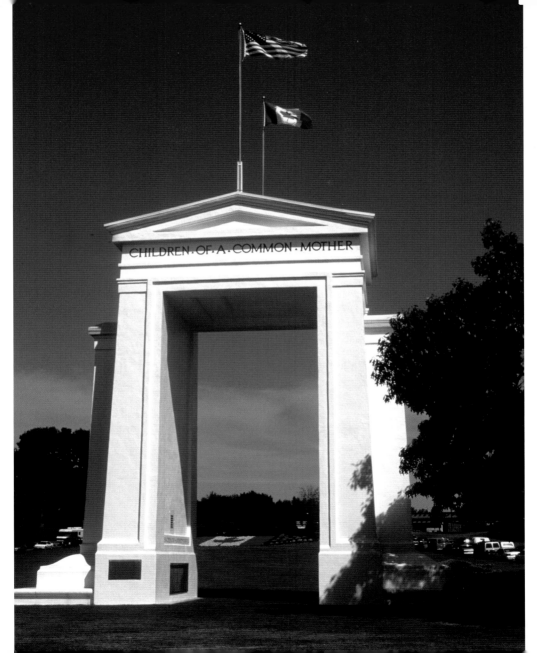

PIKE PLACE MARKET

Next to the Space Needle, Seattle's downtown Pike Place Market is probably Washington's most well-known icon. It's certainly one of the state's most popular destinations. Opened on a rainy Saturday in August 1907 so that local citizens could purchase fresh produce direct from local farmers at reasonable prices, what locals simply refer to today as the Market draws more than ten million visitors a year. They come to get their picture taken with the market's unofficial mascot, a 550-pound bronze piggybank known as Rachel. They meet friends and family under the giant neon-lit clock. They look out over the Elliot Bay waterfront. And they wander through an underground maze of eclectic stores and aboveground halls that host street performers and musicians, craftspeople, all manner of restaurants, and shops and stalls offering everything from cheese, spices, and fresh-pressed cider to caught-this-morning fish and picked-this-morning fruit, vegetables, and flowers.

Scratch the surface and you'll also learn that the market has a cultural,

Pike Place Market Between First and Western Avenues and Union and Stewart Streets (206) 682-7453 www.pikeplace market.org

political, and social history that's as tasty as the perfectly placed produce and as colorful as the fresh flowers. At times, that history has also been quite controversial. During World War II, for example, the Japanese-American farmers who rented most of the market's stalls were forced to give up their stands, their farms, and pretty much everything else, and relocate to inland internment camps. And over the years, there have been proposals to bulldoze the market and use the prime downtown real estate for everything from hotels and high-rise office buildings to a hockey arena and a giant parking lot.

None of those "urban renewal" plans worked. Instead, local citizens mounted a campaign to preserve the grounds of the market and keep its spirit and role in the community intact. Today the Pike Place Market is one of the oldest continually operating farmer's markets in the country and a bustling urban oasis where customers can still stop by to "meet the producer" much as they did more than a century ago.

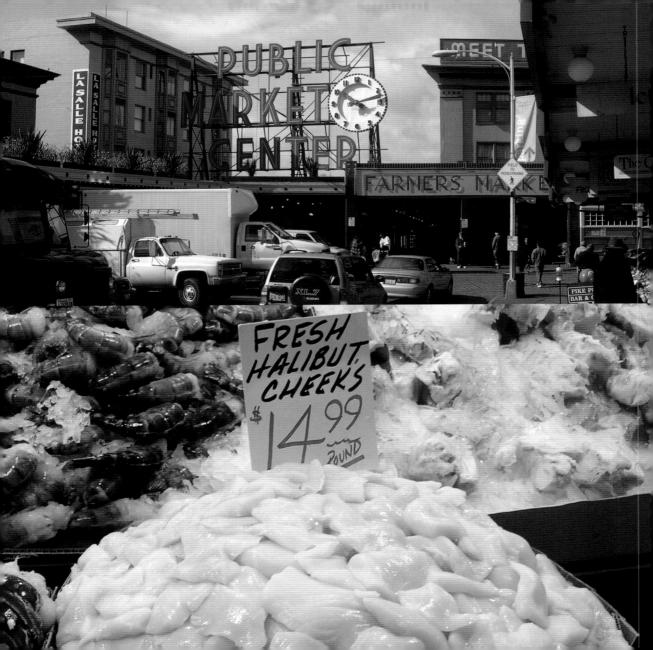

THE DOWN JACKET

Wool coats are no match for cold, rainy winter days in the Northwest woods.

Eddie Bauer, who grew up hunting, fishing, playing tennis, and hanging around outside as much as he could, learned that the hard way.

Sometime in 1935, Bauer was out on a fishing trip on Washington's Olympic Peninsula and nearly froze to death. The experienced outdoorsman and Seattle sporting-goods shop owner had dressed for a cold day, but ended up setting his woolen jacket aside when it got wet, soggy, and too heavy to wear.

Bauer successfully avoided hypothermia and came home determined to find a way to make lightweight clothing that would be able to keep the wearer both warm and dry in extremely cold temperatures. He remembered his Russian uncle's stories about how a coat lined with goose down had helped him stay alive while fighting in the Russo-Japanese War (1904-1905) and battling temperatures that reached fifty degrees below zero. So Bauer fiddled around with some goose down he happened to

have in stock for fly-tying and badminton shuttlecocks, a sewing machine, and some unbleached muslin.

He came up with a design for a jacket covered in quilted pockets of insulating down and made up a few sample jackets for a few friends. By 1936 Bauer was manufacturing what he dubbed the Skyliner jacket for others. It sold for $34.50, was made of muslin that had been dyed a forest green, and had knitted, alpaca-lined sleeves. Demand was so great that the company could barely keep up with orders.

The Skyliner quilted down jacket, which was carried in the company's catalog until 1995, spawned a long line of quilted garments in dozens of colors and styles. It also kicked off a revolution in outdoor wear. Today, quilted down jackets are standard-issue gear for just about any outdoor activity, from walking the dog to climbing a mountain, and an essential part of the laid-back everyday uniform of pretty much anyone who lives, plays, works, or steps outside on a cold, rainy day in the Northwest.

RAIN AND RAIN FORESTS

Tell someone you live in Washington or that you're on your way out the door to visit Washington State, and the first response you'll get will likely be, "I hear it rains a lot out there."

Yup, that's true. It's also false. And generally it depends on which side of the Cascade Mountains you're on. Head east of the mountains and you'll find many areas that are dry and sunny most of the year. There are even some parts of southeastern Washington where it rains so little that areas are considered desert.

West of the mountains, though, it's a much different story. Seattle, which has a reputation as the rain capital of the world, is rainy much of the year. But the city actually gets less annual rainfall than Chicago, Houston, Miami, and New York City. The difference is that in Seattle the yearly thirty-six to thirty-eight inches of rain arrives not in big downpours, but in dribs and drabs over many drizzly, gray, cloudy days.

Where it does rain a lot is in the lush, mossy rain forests on Washington's Olympic Peninsula, in the northwestern part of the state. In fact, some of the protected forestlands in the

Olympic National Park
www.nps.gov/olym/planyourvisit/upload/record%20trees.pdf

Olympic National Park are officially recognized as the wettest spots in the continental United States. Parts of the Hoh Rain Forest, for example, average an almost incomprehensible twelve feet of rain every year. And on the highest point on the peninsula, Mount Olympus, it snows an estimated fifty feet a year.

You can see the impact of all that rain and snow in the forests of the Hoh, Queets, and Quinault River Valleys in Olympic National Park. These rain forests are the largest in North America and in addition to being home to a multitude of moss, mushrooms, slugs, and all manner of forest creatures, these rain forests contain massive old-growth trees that may live to be more than 1,000 years old, grow to be more than 200 feet tall, and expand to more than twenty-three feet around. Many of the tremendous trees growing in Washington's rain forests aren't just big: Some Sitka Spruce, Pacific Silver Fir, Western Hemlock, and Douglas fir have been measured from tip to toe (no easy feat) and are listed as champions in the National Register of Big Trees.

SALMON

Check your pockets.

If you have some loose change in there, spread it out and see if you have one of the Washington State quarters the U.S. Mint released into circulation in 2007. Like all quarters in the 50 State Quarters program, the heads (obverse) side of the coin bears the familiar image of George Washington, the president for whom our state was named. The tails (reverse) side of the coin features a big salmon jumping out of the water. Now, of all the symbols to choose from (trees, mountains, coffee, or perhaps another portrait of George Washington), why would a fish land on our quarter? Because the salmon has been a touchstone of nourishment and tradition for Native Americans here as long as anyone can remember, and today the fish remains an important part of Washington's economy, culture, and identity.

Wild salmon are usually found at sea, but when it comes time to spawn they seek the freshwaters where they were born. That urge to go home often sends them swimming hundreds of miles upstream, where they will die after laying and fertilizing their eggs. That journey,

Hiram M. Chittenden Locks (or Ballard Locks), Seattle www.seattle.gov/ tour/locks.htm

complicated, exhausting, and fraught with obstacles, is an awe-inspiring mystery that only adds to the salmon's allure.

At one time, salmon runs on the Columbia River were so plentiful that annual harvests of millions of tons of Chinook, Pink, Sockeye, Coho, and other salmon barely put a dent in the seemingly ever-renewing supply. But over the years, overharvesting, commercial and sport fishing, timbering, pollution, industrialization, and the damming of the Columbia River in multiple places has reduced wild salmon migration by a figure some experts estimate to be nearing 97 percent. Pacific salmon have disappeared from much of their historic breeding range in Washington and other Pacific Northwest states, and many locally distinct salmon have been placed on the list of extinct, endangered, or threatened species.

Once an icon of abundance, wild salmon are now a symbol of caution. And perhaps hope: Native American, industrial, and government groups are working together to try to save and restore Washington's wild salmon stock. Let's hope they do.

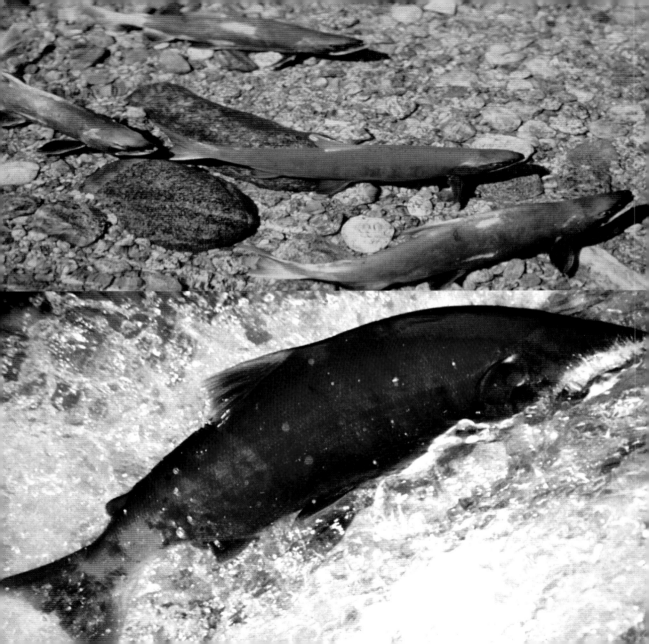

SEATTLE CENTRAL LIBRARY

Thrilling, surprising, and enter-taining are the sort of words you might use to describe a character or plot twist in a book you've checked out from the library. In Seattle those terms, along with *awe-inspiring, groundbreaking,* and *exhilarating,* are just as likely to be called upon when describing an iconic, if odd-looking, public building built to hold more than 1.45 million books.

Seattle's Central Library building is a glass-clad, eleven-story structure designed by Pritzker Prize–winning architect Rem Koolhaas. The unique structure sits on the downtown block that has housed the city's main library buildings for more than century. The original library on this spot opened in 1906. Built with funds donated by philanthropist and library-booster Andrew Carnegie, the original beaux-arts building was replaced in 1960 with one featuring a modern, international design and endowed with amenities such as air-conditioning, a drive-up service window for book pickups, and the first escalator in an American library.

**Seattle Central Library
1000 Fourth Avenue, Seattle
(206) 386-4636
www.spl.org**

New and unusual was still on the menu when it came time for Seattle to build a library for the 21st century. Opened to great fanfare in 2004, the newest central library building is strangely shaped, off-kilter, and covered with a diamond-patterned, earthquake-safe skin made of glass and steel. Inside, there's a soaring, atrium-style "living room" lobby and a light-filled, tenth-floor reading room offering dramatic views of downtown and Elliot Bay.

Instead of storing books on separate floors, shelving curls through four floors of uninterrupted book stacks in the center of the building. Connected by chartreuse-colored escalators, stairs, and elevator cabs, the Books Spiral houses most of the library's nonfiction books (about 75 percent of the library's overall collection) in one continuous Dewey Decimal System run.

Part library, part tourist attraction, Seattle's Central Library building has won numerous awards and is visited by locals and tourists who stop by not to read a book but to simply ogle the building and enjoy the views.

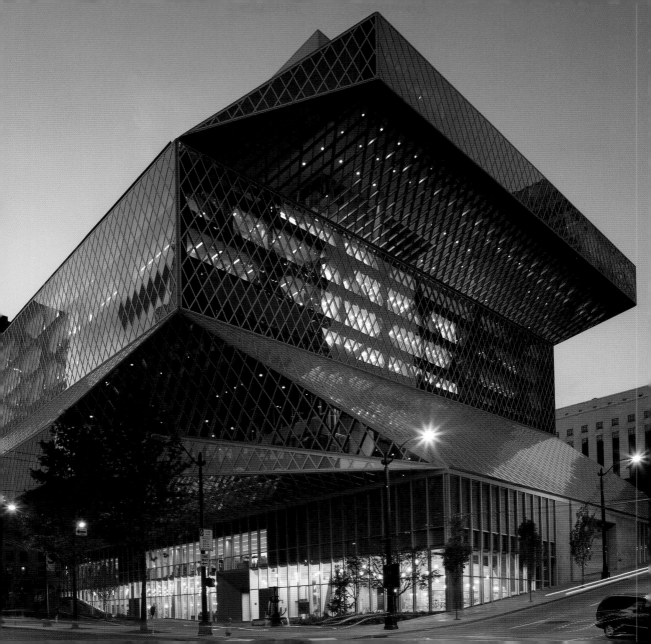

SLINKY PULL TOYS

American children were first introduced to the Slinky in the 1950s. And while the coiled "walking" toy wasn't born in Washington State, it was a Seattle woman's smart idea that helped ensure that the fun springy-thing was more than a wobbling one-trick wonder.

A mechanical engineer from Pennsylvania, Richard James, gets credit for inventing the Slinky back in 1943. Working in a naval shipyard during World War II, James got a giggle out of the way a torsion spring fell off a table, wiggled, and regained its original shape. He thought it might make a fun plaything and by 1945, an eighty-foot coiled-wire toy, coined the Slinky by James's wife, Betty, appeared in stores.

On its own, the basic Slinky was a steady seller. But all it could really "do" was flip end-over-end down a set of stairs and, if the conditions were just right, recoil itself neatly at the bottom. So when her son got a Slinky for Christmas in 1952 and mused about how the toy might be more interesting if it had

www.poof-slinky .com

wheels, Seattle housewife Helen Herrick Malsed sprang into action. She sent her husband to the basement and instructed him to cannibalize a set of wheels from another toy, fire up the soldering gun, and attach the wheels to the standard-issue Slinky. Then Malsed attached a string from a window shade to the Slinky. Voilà! The first Slinky pull toy was invented.

Malsed sold her ideas for the Slinky Train, the Slinky Dog, and other Slinky pull toys to Slinky inventor Richard James, and the Slinky product line jumped to the top of the toy charts. To date, more than 300 million Slinky toys have been sold worldwide, and the original Slinky has been inducted into the National Toy Hall of Fame.

But it was a Slinky pull toy that made it into the movies. An animated dachshund version of the original Slinky Dog has had supporting roles in the Pixar (now owned by Disney) animated movies *Toy Story* and *Toy Story 2,* thus endearing Slinky pull toys to a whole new generation.

SMITH TOWER

As sales gimmicks go, it was a whopper.

In 1909 Lyman Cornelius Smith, who'd earned a fortune manufacturing and selling rifles and typewriters back east, decided to build a fourteen-story office building in Seattle. But his son, Burns Lyman Smith, convinced his dad to scrap that idea in favor of a structure that would capture the world's attention and, hopefully, sell more office equipment. They decided to build the tallest office building outside of New York City.

The plan worked. When Seattle's first skyscraper opened, on July 3, 1914, it was crowned the tallest building west of the Mississippi and celebrated far and wide not only for its height (522 feet, just thirty-three feet short of the Washington Monument), but for its luxurious detailing, which included Alaskan white marble wainscoting, bronze window frames, and a fleet of eight brass-caged elevators. Built with 165 railroad cars worth of fabricated steel and clad in granite and white ornamental terracotta, the forty-two-story Smith Tower

*Smith Tower
506 Second
Avenue, at the
northeast corner
of Yesler Way,
Seattle
(206) 622-4004
www.smithtower
.com*

was also supermodern and "wired" for business: Each of the 540 offices had two telephone outlets, two telegraph outlets, 660 watts of electricity, and its own vacuum cleaner. Tenants had to supply their own office equipment, but no doubt that machinery would include a few Smith-made typewriters.

The office spaces have been reconfigured somewhat over the years, but those operator-run, polished-brass cage elevators and their original DC motors, remain. So does what has been called the crown jewel of the building: the thirty-fifth floor outdoor observation deck that wraps all the way around the sumptuous Chinese Room, which is decorated with a hand-carved wood and porcelain-inlaid ceiling, antique temple doors, and other ornate furniture that was a gift from Tzu-His, the dowager empress of China. The intricately-carved chair known as the "Wishing Chair" didn't come from the empress, but legend has it that any unmarried woman who spends a few minutes sitting in the chair will be married within one year. Try it and see.

SNOQUALMIE FALLS

Whether they're pounding and powerful or peacefully pouring from a ledge, waterfalls draw crowds. We seek them out because they're beautiful and mesmerizing, of course, but also because they make us feel good: Rushing water gives off negative ions, which help create a biochemical reaction that relieves stress and induces feelings of calm.

That's just part of the draw of Snoqualmie Falls, which ranks just behind Mount Rainier as Washington's most popular attraction. Located in a two-acre park about thirty miles east of Seattle, the iconic 268-foot waterfall is 100 feet higher than Niagara Falls and is reputed to be a powerful and historically sacred site for the Snoqualmie Tribe and other native people of the region.

Since the mid-1800s, when white settlers followed the Snoqualmie River to the falls, the site has also been a tourist destination. Later, it also became a source of electric power. In 1889, the first passenger excursion train reached the falls and legend has it that more than 1,000 curiosity seekers showed up

Snoqualmie Falls
Thirty miles east of Seattle, about a mile north of Snoqualmie
(425) 888-4440
www.snoqualmie valleytourism .com

to see French daredevil Charles Blondin (of Niagara Falls tightrope fame) cross the falls on a rope. Around that same time, the world's first completely underground power plant began operation below the base of the falls. That plant, plus a second one built in 1910, is still in operation and was declared a civil engineering landmark in 1981, in part because much of its original equipment is still in use.

Naturalist John Muir was a fan of Snoqualmie Falls, as were devotees of the quirky early 1990s cult TV drama, *Twin Peaks,* which used a shot of the famous falls in the opening credits of each episode. Today, close to two million visitors stop by the falls each year. And though throughout the year much of the water from the river gets diverted from the waterfall and into the power plants, the falls are still a popular and spectacular sight. Especially when viewed from the restaurant in the nearby Salish Lodge, the observation deck that sits 300 feet above the river, or from the trail that leads to the base of the falls.

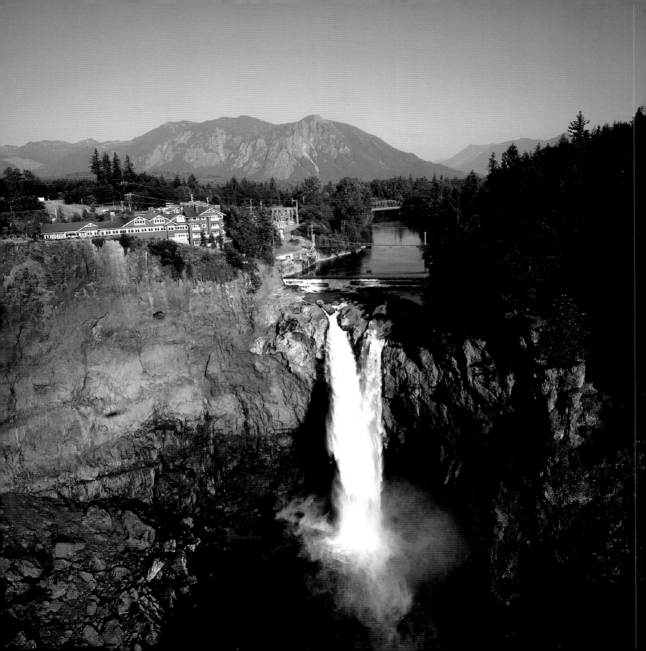

SPACE NEEDLE

The Space Needle is not just Seattle's No. 1 tourist destination; it was once the tallest building west of the Mississippi and remains one of the city's most unusual structures. Even better, it's got a restaurant that spins.

Hovering above the Seattle skyline like something out of *War of the Worlds,* the Space Needle (originally called the Space Cage) was built to blend in with the futuristic Century 21 theme of the 1962 Seattle world's fair.

The building's early design was inspired by Germany's sticklike, concrete Stuttgart Tower and initially sketched out on a coffeehouse placemat by Edward E. Carlson, who was then the president of Western International Hotels. Carlson envisioned a building topped by a structure resembling a tethered balloon. But after architect John Graham and his team made some structural refinements, the Space Needle became a 605-foot-tall, three-legged tower with a flying-saucer-shaped dome at the top and glass elevators that could make the trip from ground level to top-dome in forty-three seconds flat.

Space Needle at the Seattle Center
400 Broad Street, near the Seattle Center House at 5th Avenue North and Broad Street
(206) 905-2111
www.space needle.com.

Today, as then, the "flying saucer" at the top of the Space Needle houses an indoor/outdoor observation deck offering (on clear days) amazing views of the city, the skyline, Puget Sound, and the Cascade and Olympic Mountains. There's also a revolving restaurant up there. Originally called the Eye of the Needle, the dining venue is now known simply as SkyCity. The smoking Lunar Orbiter dessert introduced in 1962 is still on the menu and the restaurant itself is still kept in motion by a simple, energy-efficient 1½ horsepower electric motor. And while rotating restaurants are not that unusual today, back in 1962 the Space Needle was only the second revolving restaurant in the world. (The first one, now closed, was in a shopping mall in Hawaii.)

The Space Needle is also no longer Seattle's tallest building, but it most definitely remains the city's most iconic image, with its own set of paint colors (including Astronaut White, Orbital Olive, and Re-entry Red), a Web cam, and City of Seattle landmark status.

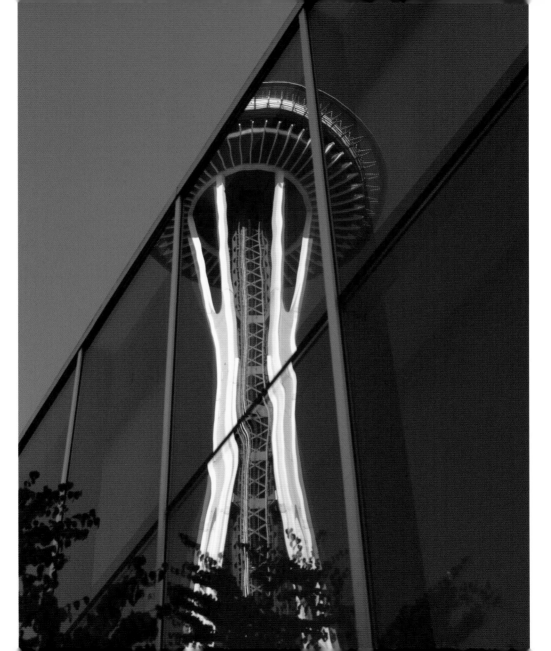

STARBUCKS

Coffee and coffee beans existed for ages before 1971, when three friends opened a little shop called Starbucks Coffee, Tea and Spices in Seattle's Pike Place Market, taking the Starbuck name from the first mate on the ship in Herman Melville's novel, *Moby Dick*. Back then, the team's stated goal was to sell fresh-roasted coffee beans and high-end coffee-making equipment so that customers could brew and drink great-tasting coffee at home. Brewing and serving coffee in the store wasn't on the agenda. Neither was the idea of becoming the world's largest coffeehouse company.

But things change.

A marketing guy named Howard Shultz showed up. And, as the story goes, Shultz was buzzing not just from all the great espresso he'd been sipping on a trip to Italy, but from the experience of being able to sip that espresso in coffee shops that were on just about every corner and that doubled as gathering spots for all sorts of people. Shultz eventually bought what became the Starbucks Coffee Company and helped transform the beans-only business

The "original" Starbucks coffee store Pike Place Market 1912 Pike Place, Seattle

into a beans-and-brew (and eventually gifts, books, music, and more) business. Today, with more than 15,000 company-owned and licensed outlets through the world, the ubiquitous Starbucks brand is now almost synonymous with the coffee-drinking experience.

These days, the purveyor of drinks caffeinated, decaffeinated, and frothed can be found in neighborhoods, malls, airports, grocery stores, hotels, department stores, office buildings, and in countries around the world.

Starbucks coffee drinks can also still be found at Seattle's Pike Place Market: While the founding store moved from its original location in 1976, it remains open for business at its "new" nearby location. Visitors to that store will find many original fixtures, including the original Starbucks Coffee, Tea and Spices sign and the earliest version of the Starbucks logo, which once featured a topless siren with an obvious double fish tail. The siren has been tamed a bit over the years—the current logo features a more modest siren with just a hint of fish tail—but the coffee drinks still deliver the same caffeinated kick.

THE TACOMA DOME

Today, sports domes of all shapes, sizes, and materials dot the countryside. Back in 1981, though, it was news when the city of Tacoma announced that its new sports and event venue would be the largest wood-domed structure ever built. And for a short while after August 11, 1983, when David Bowie kicked off the Tacoma Dome's first major concert, it was.

The $44 million circular building contains enough concrete for seventy miles of sidewalk. Its 152-foot-high dome includes 1.6 million board feet of glue-laminated beams made out of old-growth Douglas fir timber from Oregon and layered into place in 5,000-pound triangular pieces. When it came time to top the building with the final star-shaped piece, builders trucked the big beams downtown so citizens could sign their names with a thick black marker. Today anyone lucky—and brave—enough to clamber up on the dome's catwalk can still see thousands of those autographs, including Terry McKee's. McKee, who was the Tacoma Dome's project engineer, has vivid memories of how his crew practiced putting that last

The Tacoma Dome Adjacent to Interstate 5, downtown Tacoma

heavy piece in place before TV crews came by to film it. "We just wanted to make sure it fit so we didn't look bad to the whole world."

What modern-day Tacoma Dome visitors won't see is the giant flower Andy Warhol envisioned for the exterior or the interior of the dome, nor the constellation design proposed by noted muralist Richard Haas. The dome's $280,000 public art commission instead went to Stephen Antonakos, who made a pair of neon art panels for the inside of the dome.

And how did this iconic wood-domed building gets its plain-Jane name? Some of the names put forth by citizens included the Bing Crosby Dome (the crooner was born here), the Rhododen-dome (the well-known Rhododendron Species Botanical Garden is nearby), and the Tacoma Termite Terrarium (due to all that wood). But, according to a newspaper insert celebrating the April 1983 opening of the Tacoma Dome, the city council decided that a name that "told both *where* the building was and *what* it was" just made more sense.

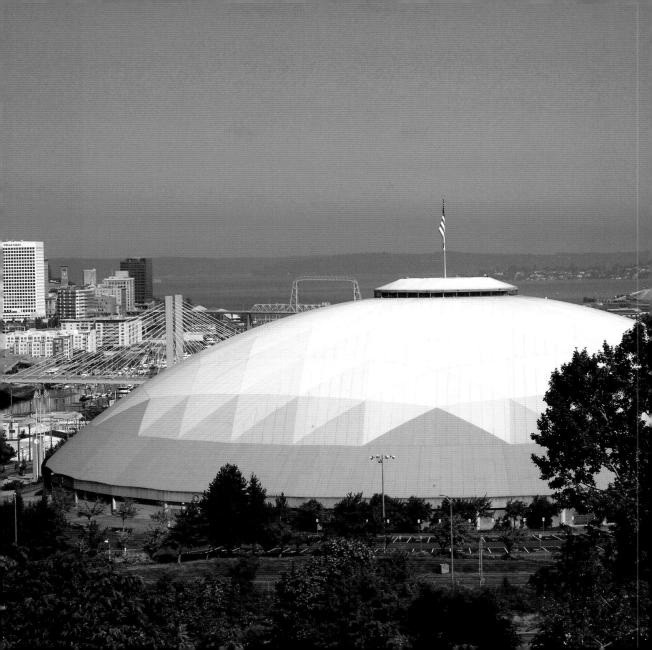

TEAPOT DOME SERVICE STATION

Government scandals often inspire demonstrations, newspaper editorials, and heated discussions in bars and cafés and at dinner tables. But rarely do political wrongdoings motivate someone to construct a building that, years later, still causes travelers to drive miles out of their way just to see it. But that's exactly what happened back in 1922, when a Zillah-area resident got riled up by the news surrounding the Teapot Dome oil reserve debacle that took place during President Warren G. Harding's administration.

A year earlier, President Harding had transferred control of naval oil reserves at Teapot Dome, Wyoming, and Elk Hills, California from the Navy to the Department of the Interior. Then Secretary of the Interior Albert Fall leased those oil fields to private oil companies in exchange for personal "loans" that were later determined to be bribes. A Senate investigation ensued, fines were issued, people went to jail, and in 1927 the oil fields reverted back to government control.

While the scandal was unfolding, however, Zillah-resident Jack Ainsworth

Teapot Dome Service Station Old State Highway 12, Zillah (fifteen miles southeast of Yakima on Interstate 82)

wasn't content to just sit around playing cards and grumble about the situation to his friends. Instead he decided to build a whimsical and hard-to-ignore highway memorial to the political wrongdoing: a gas station in the shape of a fifteen-foot-tall teapot, complete with conical roof, sheet-metal handle, and concrete spout.

Long after the details of the scandal were forgotten, the Teapot Dome Service Station continued to operate as an architectural folly that dispensed both fuel and a fun history lesson. When it closed for business after being moved and rebuilt at least once, the teapot was one of the oldest functioning gas stations in the United States.

Listed on both the National Register of Historic Places and, since 2007, on the Washington Trust for Historic Preservation's list of "most endangered properties," the iconic teapot now waits for the Friends of the Teapot to gather enough funds to move the structure to town. There, the teapot steeped in history will serve as a tourist information booth.

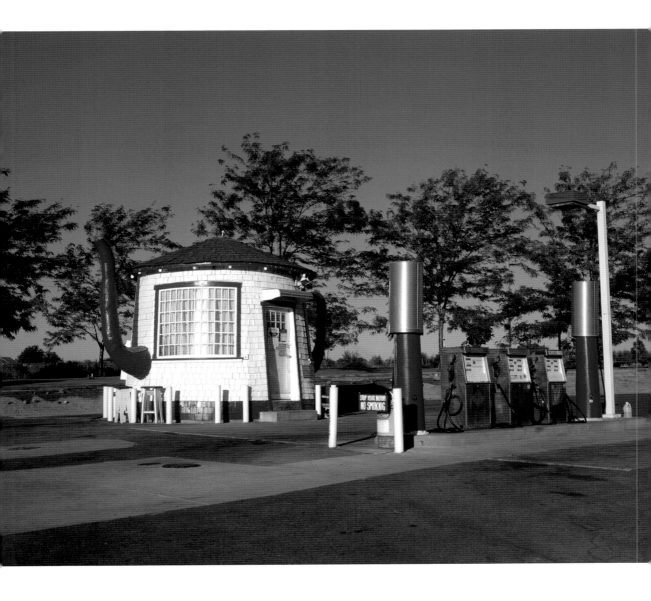

THE RACING STROLLER

Parents give up a lot of things when they have kids—sleep, privacy, and the ability to have an uninterrupted adult conversation, to name just a few. But in true baby-boomer form, back in 1983 when Yakima resident Phil Baechler became a father, the avid marathon runner wasn't willing to give up his newspaper job, his training regimen, or the privilege of spending quality time with his infant son. So Baechler decided to figure out a way to take baby Travis along with him on his daily runs. But how? Classic baby strollers were flimsy and not built for speed or distance. And a baby could get seriously hurt being bounced around in a backpack.

Taking his cue from those tot-size covered trailers designed to be pulled behind bicycles, Baechler began buying and taking apart yard-sale strollers and reassembling them with assorted cast-off bicycle parts he had stored in his garage. After a bit of tinkering, he emerged with a lightweight but sturdy stroller that incorporated a bicycle-fork, three bicycle-style tires, and a slinglike seat for the baby. Now dad and baby could hang out together and even run

in races, although they did get some strange looks.

Baechler patented his Baby Jogger stroller in 1984 and, with his wife and a friend, formed a company to manufacture the newfangled baby buggies for other active parents who were soon clamoring for the rugged, funny-looking strollers. As the business grew, so did the pram family, with all-terrain models designed for running with two children, compact versions for city dwellers heading out for urban adventures with their babies, and strollers that could accommodate the needs of children with disabilities.

These days, the Baby Jogger Company is part of the Dynamic Brands portfolio, but the somewhat pricey, modern-day performance-perambulators are still popular and highly sought after in Washington and around the world. And not just by active parents seeking a high-tech way to tote their tots. Open a Hollywood gossip magazine and you'll likely find paparazzi-style photographs of a few celebrity moms and dads using their Baby Jogger stroller as a fashion accessory.

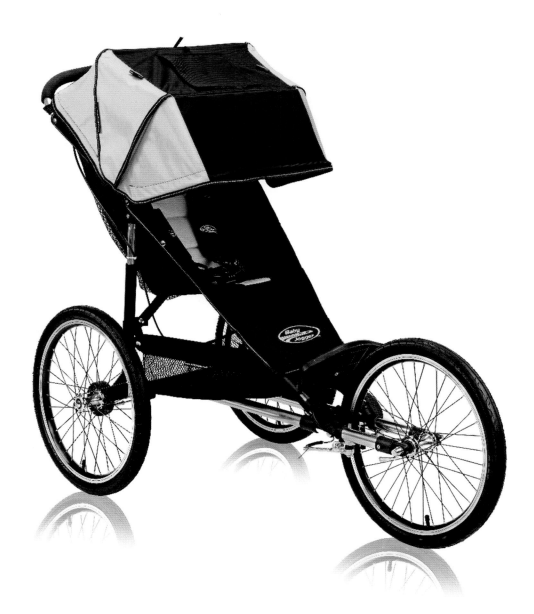

TULIPS

To every thing, they say, there is a season. And in Washington's lush Skagit Valley, about seventy miles north of Seattle, each spring the "thing" is flowers. But not just any flowers, mind you. Not roses, not daisies, and not even the lovely Pacific rhododendron, or *Rhododendron macrophyllum,* which the women of Washington State picked as the state flower from a slate of six blossoms in a special ladies-only election back in 1892. No, the spring flowers that lure more than a million visitors a year to the Skagit Valley's commercial flower farms are the daffodils, tulips, irises, and lilies that create colorful carpets of blooms.

Exactly when each flower reaches its peak viewing time is, of course, up to Mother Nature, but in general the season unfolds first with bright and sunny shades of yellow daffodils in mid- to late-March. Then, it's a veritable rainbow of tulips in April, followed by irises and lilies in May.

The tulips are really the main attraction, though. Perhaps that's because they come in so many sizes, shapes, and colors. Or perhaps it's

*Skagit Valley Tulip Festival
(360) 428-5959
www.tulipfestival.org*

because, with more than 500 acres of tulip fields, Washington has one of the largest tulip plantings outside of Holland, yielding millions of brilliant flowers each year. Or maybe it's because, after months of gray winter weather, folks in the northwest crave a burst of color. Whatever the reason, the tulips and other flowers that fill the fields here are hard to ignore. So each April, the towns of La Conner, Mt. Vernon, and the surrounding Skagit Valley communities get gussied up and celebrate the season with a Tulip Festival that includes a bouquet of more than forty petal parties ranging from a tulip run and a tulip pedal to a tulip parade and a wide assortment of other flower-themed fun.

Of course, all those flowers will eventually get picked and then they'll eventually wilt. But as a reminder that another flower-filled spring is always just around the corner, the town of Mt. Vernon has a permanent forget-us-not message on the edge of town. The town's landmark smokestack, clearly visible from Interstate 5, is painted to resemble—you guessed it—a giant bunch of tulips.

WALLA WALLA SWEET ONIONS

A sweet onion. Like a jumbo shrimp, a baby grand, friendly fire, and a final draft, it sounds like an oxymoron. But don't say that to the folks in the Walla Walla Valley. They've been growing sweet onions there for more than a century, ever since a soldier named Pieter Pieri showed up with some onion seeds he'd picked up on Corsica Island, off the west coast of Italy. Area farmers, many of whom also hailed from Italy, became enamored with the unusual taste of those imported onions and impressed with the hardiness of the seeds. And over several generations of careful selection and cultivation, they developed what has become known as the reliably sweet and mild jumbo-size Walla Walla Sweet Onions.

What makes them sweet? It's not sugar. Sweet onions are about 90 percent water, with thick juicy layers. They've got a sulfur content that's about half of what the familiar thin-layered, pungent yellow onions usually have. In fact, a Walla Walla onion is so sweet and mild-tasting that it's not unusual to see someone eat one of these onions raw, in the

Walla Walla Sweet Onions
(877) WWVISIT
www.sweet
onions.org

same way they'd consume a fresh, crisp apple: one enthusiastic bite at a time.

Today more than 1,000 acres of choice farmland in southeastern Washington is devoted to growing Walla Walla Sweet Onions and more than twenty-seven million pounds of the surprisingly sweet vegetable are harvested and shipped to market each year. Although sweet, the water-packed onion is also somewhat perishable: Even under ideal (cool and dry) storage conditions, once a Walla Walla Sweet Onion is picked it has a shelf life of just two or three weeks.

Being so perishable doesn't seem to detract at all from the Walla Walla Sweet Onion's popularity. Every summer crowds gather in Walla Walla for a Sweet Onion Festival that includes cooking competitions (onion ice cream, anyone?) and sweet onion–eating contests. And in 2007, despite the initial protestations of the state's proud and productive potato farmers, the governor of Washington designated Walla Walla Sweet Onions as the official vegetable of the Evergreen State. Sweet!

WASHINGTON
STATE CAPITOL BUILDING

Washington State's capitol building, called the Legislative Building, is the centerpiece of the Olmstead Brothers–designed fifty-acre Olympia Capitol Campus. The lovely landscaped grounds offer sweeping views out to Puget Sound and are home to a variety of governmental buildings, the Governor's Mansion, a greenhouse, sunken gardens, an exact replica of a fountain from Copenhagen's Tivoli Gardens, numerous monuments, and a 260-acre lake.

Appropriately enough, it is the Legislative Building that is the largest and most impressive part of the campus. Built at a cost of $7.4 million between 1921 and 1928, the building is topped by a dome that sits 287 feet above the ground and is the fourth-largest masonry dome in the world after St. Paul's Cathedral in London, St. Peter's Basilica in Rome, and St. Isaac's Cathedral in St. Petersburg, Russia.

Six bronze-cast entry doors, each weighing five tons, bear bas-relief images of scenes from Washington's history, including a sailing ship, logging activity, and scenic landscapes. Inside the build-

Washington State Capitol Visitor Center
(360) 586-3460
www.ga.wa.gov/
visitor/tour.htm

ing, there's plenty to impress as well. There's a time capsule beneath the floor of the North Vestibule, and embedded in the floor of the rotunda is a giant seal of the State of Washington. Suspended fifty feet above the rotunda's floor is a five-ton bronze chandelier with 202 bulbs that's big enough to hold a Volkswagen Beetle. The chandelier bears the mark of Louis Comfort Tiffany and is the largest chandelier ever created by the Tiffany Studios. Tiffany also created hanging lamps, lanterns, outdoor lighting fixtures, and other items for the building in what turned out to be his last major commission prior to his death.

While the capitol now contains the largest collection of Tiffany bronze, it also houses some other treasures. Hanging in the State Reception Room is the original Washington State flag and a forty-two-star American Flag, one of four in the state's possession. And on a balcony overlooking the rotunda is a large bust of George Washington. His nose is all shiny not because he has a perpetual cold, but because so many visitors have come by to rub it for good luck.

WHALES

Thousands of years before it became Washington's official state marine mammal, the black and white orca, or killer whale, already had an important role in the spiritual and cultural lives of Northwest Coast Indians. Yet while they are honored by several tribes as an ancestral spirit and a symbol of strength and bounty, and they are the most researched and watched whales in the world, the eighty or so whales in Washington State's three orca packs or pods (the Southern Resident community) have been on the endangered species list since 2005.

Technically not whales but members of the Delphinidae, or dolphin, family, orcas have no natural predators. They live in matrilineal family groups, grow up to twenty-seven feet long, and weigh in at up to 9,000 pounds. Each pod has an elder matriarch as the leader and its own unique "dialect," or set of calls. And while in other parts of the world, orcas are known to eat seabirds, seals, porpoises, otters, and other small animals, the Southern Resident orcas—

The Whale Museum Friday Harbor in the San Juan Islands (360) 378-4710 www.whale museum.org

known affectionately as the J, K, and L pods—feast mostly on Chinook salmon.

The best place to see the orcas is in the San Juan Islands, and each year more than 500,000 people head there to go whale watching on both commercial and private boats. Many others spot the whales from shore, most notably from Lime Kiln State Park, which sits on the west side of San Juan Island and is considered to be one of the best land-based whale-viewing spots in the world. And while orcas are most frequently spotted from May through September, members of the J pod are often spotted year-round.

Orcas aren't the only whales that travel along the Washington coast. Gigantic gray whales, which can reach fifty feet long and weigh up to thirty-six tons, pass by twice each year: in November and December on their way south to breeding grounds off Mexico, and between April and June when they head back north to feeding grounds in the Arctic seas.

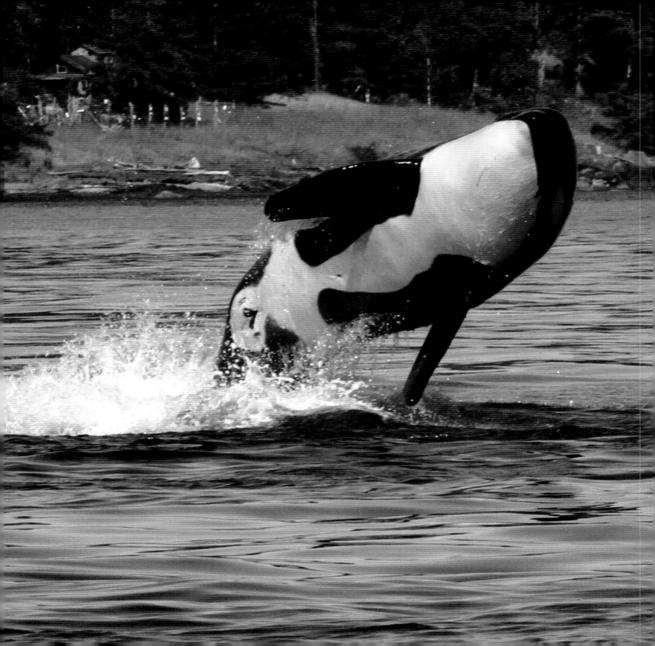

WORLD'S LARGEST EGG

Many western Washington towns have histories rooted in timber and farming. Winlock, in Lewis County, was one of them. But starting back around 1914, Winlock-area chicken farmers began using "modern-day" incubators and the latest methods of scientific egg production. The area hatched a thriving poultry industry that earned Winlock the title of Egg Capital of the World.

Winlock took advantage of its location on the railroad line and served as a central shipping hub for newly hatched chicks and freshly-laid eggs from throughout the region. By the early 1920s Winlock was recognized as the country's second-largest egg-producing town, and for a time during the 1930s it was not unusual for more than two million eggs to leave the train depot each year destined for restaurants, bakeries, and breakfast tables as far away as New York City and London.

The egg farms were long gone by the 1950s, but the folks in Winlock are still proud of their poultry past. So darn proud, in fact, that each June they still

Winlock's egg Exit 63 from Interstate 5, west to Winlock on Highway 505

celebrate Winlock Egg Days in the same way they've been doing it since 1921: with the crowning of an Egg Queen and her court, and a festive, float-filled parade that's followed by an informal luncheon that includes free homemade egg-salad sandwiches on white bread for all.

And despite competing claims and corny cracks from the folks in Mentone, Indiana, and Vegreville, Canada, Winlock's elected officials still insist, as they have since 1923, that the town is the original home of the World's Largest Egg. Now in its fourth incarnation, Winlock's extra-large egg is made of three tons of fiberglass, concrete, plaster and, yes, plenty of chicken wire. Weighing in at 1,200 pounds, the fourteen-foot-long, seven-foot-tall egg is about the size of a Volkswagen Beetle and sits high on a pedestal in Vern Zander Memorial Park by the railroad tracks in the center of town. Largest or not, Winlock's giant egg is an ovoid, iconic homage to Washington State's agricultural egg-cellence.

YE OLDE CURIOSITY SHOP

A taxidermy mermaid, a petrified dog, a tugboat made of matchsticks, and a shelf filled with shrunken heads. The jawbone of a whale, a rarely seen jackalope, Siamese-twin calves, and a pickled baby pig with far too many feet.

For more than a century, oddities like this, along with a dizzying mashup of exotic keepsakes, tacky trinkets, and authentic handiwork purchased and commissioned from Eskimos and Native Americans, have lured both locals and tourists to the Seattle waterfront emporium known as Ye Olde Curiosity Shop. Founded in 1899 by a canny and eternally curious entrepreneur named Joseph E. "Daddy" Standley, and still in the family, the memento- and marvel-filled shop has always been as much a museum as a must-see souvenir stand. In fact, in its early years, the shop's customers included wealthy private collectors, curators from important universities and museums (including the Smithsonian Institution), and celebrities ranging from Robert Ripley (of Ripley's Believe It or Not! fame) to presidents Teddy

Ye Olde Curiosity Shop and Museum
Pier 54
1001 Alaskan Way, Seattle
(206) 682-5844
www.yeolde curiosityshop.com

Roosevelt and Warren G. Harding, actors Charlie Chaplin and Jean Harlow, and boxer Jack Dempsey.

They all came to shop and stare. Celebrity or not, many thousands still do. And while each visitor may spend a few minutes surveying the Space Needle salt-and-pepper sets, the keychain totem poles, the gag gifts, and the other modern-day merchandise for sale, everyone eventually ends up staring at the exotic objects hanging by wires from the ceiling and the weird and wonderful antiquities tacked to the walls. And then they head to the back of the store to be introduced to Sylvia and Sylvester, the shop's infamous mummies. As the story goes, back in the late 1800s, two cowboys moseying along in the Arizona desert discovered the perfectly preserved and dehydrated Sylvester, complete with eyelashes, teeth, and all of his internal organs shrunken but still intact. Sylvia, who may hail from South America, has been dated to the early 19th century. She's far more desiccated than Sylvester but, curiosity-wise, equally loved.

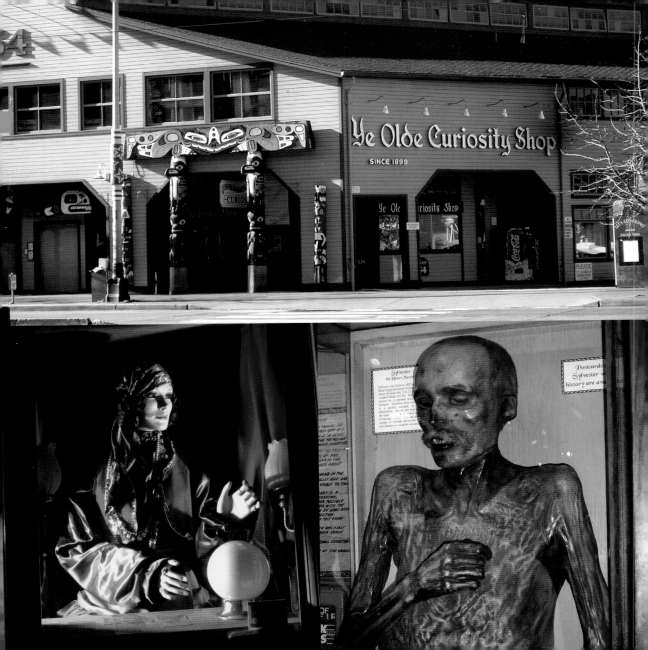

PHOTO CREDITS